The Campus History Series

HAMPTON UNIVERSITY

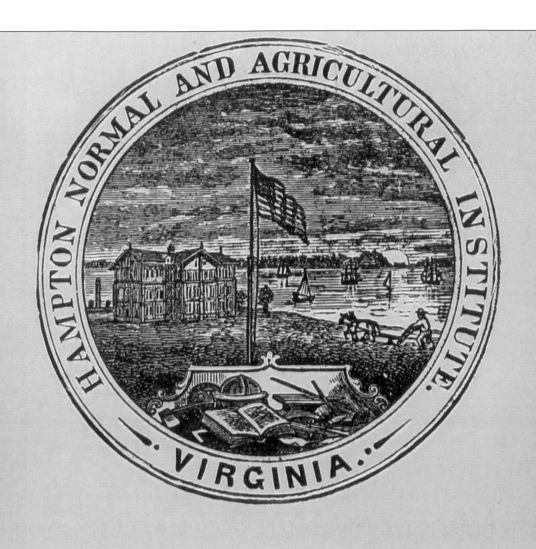

In 1962, alumni Byron Puryear published *Hampton Institute: A Pictorial Review of Its First Century 1868–1968*. On the eve of Hampton University's sesquicentennial, I submit this pictorial documentary of the history of Hampton University as told in the words of those who watched it grow. May this book serve as a tribute to all, especially Byron Puryear, whose work is available for all to enjoy. (Courtesy of HathiTrust.)

ON THE COVER: Taken in 1901 by well-known photographer Frances Johnson, this image show both African and Native American students studying the earth's rotation around the sun. (Courtesy of Library of Congress.)

The Campus History Series

HAMPTON UNIVERSITY

VERONICA ALEASE DAVIS

ARCADIA
PUBLISHING

Published by Arcadia Publishing
Charleston, South Carolina

Printed in the United States of America

Library of Congress Control Number: 2013957849

For all general information, please contact Arcadia Publishing:
Telephone 843-853-2070
Fax 843-853-0044
E-mail sales@arcadiapublishing.com
For customer service and orders:
Toll-Free 1-888-313-2665

Visit us on the Internet at www.arcadiapublishing.com

To my sons, Rashad I. Davis-Gladney and Cornell M. Burke, and to my high school history teacher Bonnie Tingle, thank you for supporting my research endeavors.

CONTENTS

ACKNOWLEDGMENTS

My decision to become an independent researcher is one that has given me great joy and at some points much sadness, but through it all, my sons have stood beside me as we have spent weekends, holidays, and birthdays in the woods, clearing graves, visiting forgotten historic sites, arguing for the preservation of historic sites, sitting on municipal and legislative historical committees, and participating in lecture series. I am glad that you both have been down for the cause.

I wish to thank the following people: First Lady Michelle Obama for acknowledging my work in the community with youth; former first lady Laura Bush for encouraging me; former Hampton mayor Molly Ward for loving history; Chris and Nicole Stewart; Mary Bunting; Margie Emmons; Arthur Howe and family; the faculty and staff of Hampton University, Yuri Milligan, Dr. Doretha Spells, Sharon Fitzgerald, and Joy Jefferson; the staff of Hampton Public Library, Liz Wilson; the Library of Congress; the Library of Virginia; HathiTrust; and University of Michigan.

I want to thank my family and friends Naomi Lowe, Gwen Billingslia, Rochelle King, Alvin Cobb, Gwendolyn Brady, Ruby Richmond, Michelle Abubakar Lisa Brass, Dr. Patricia Johnson, Cora Mae Reid, Lillie Hubbard, Dr. Mary Christian, Reuben Burrell for interviews, Dr. Walter Lovett, Lillian Lovett, Charlotte Pearson, Janet Cooper, Evelyn Stewart, Clarence "Jap" Curry, Lucius Wyatt, Eugene Johnson, Celestine and Rudy Carter, Katherine Howard, Liberty Baptist Church, Tammy Ethridge, Cindy Robertson, Randy Carter, Patrick Bales, Sandra Myrick, Rochelle Yarbourgh, Dr. Richard Singletary, Dr. Angela Odum-Austin, Linda B. Smith, Pat and Robert LeBlanc, Narcndra Pleas, Roni Gomez. Heather Emmert, Lori Butts, Agnes Turner, Matthew Glassman, Ms. Belinda, "Bishop" Staten, and Alyssa Fonoimoana. A special thank-you goes to the Tucker family for being patient as I completed this research. I would also like to thank all of my students and graduates of Hampton City Schools, all of the staff that I have worked with for over 10 years, Deborah Ballard, Chevese Thomas, Amy Rowe, Sheree Smith, Irma Burrows, Sarah Fells, Cindy Everett, Deonne Bradsher, and Lesley Tonkin.

Thanks go to Luke Coolbear, Richard Featherer, Robert Clark, and the staff of FedEx Office Print & Ship Center in Newport News, Williamsburg, and Norfolk. Ernest Roland and the Urban League of Hampton Roads were also instrumental to this project's success.

I worked hard to choose the best-quality images considering their age. There were images that presented challenges in reproducing for this publication. Arcadia Publishing was very understanding, including them due to their rarity and value in telling this visual story.

INTRODUCTION

This book—combining facts, stories, and photographs from the nearly 150-year history of Hampton University—has been written in the hope of introducing many new friends to the accomplishments of this institution, as a place of both education and empowerment for African Americans and American Indians.

The Campus History Series: *Hampton University* is a compilation of the reminisces of Gen. Samuel Armstrong, Mary Alice Armstrong, Helen Ludlow, Alice M. Bacon, Edward Jones, Dr. Frank Mavel, Bryon Puryear, Cora Mae Reid, Ruben Burrell, Katherine Howard, Eula Davis, Dr. Walter Lovett Sr., Rufus Easter Sr., myself, and many others. This book was created in reply to the demand for a visual history of the early campus, and I truly hope that you enjoy this account of how one man answered the infamous question of what was to be done with the freedmen after the Civil War, subjugation or extermination.

In *Hampton and Its Students* by Mary Armstrong and Helen Ludlow, Hampton's early history was described as follows:

> In the history of this state, there arose, long ago an unnatural relation between two races which furnished a problem dealt with by statesmen, philanthropist, and fanatics, and finally solved by God himself in his own way; and it is with an outgrowth of that problem and its solution that this book has to do. Therefore, I ask our readers to go back with me into the past of a little Virginian town. By this broad, shining sea path, there came, the daring little band of Englishmen who settled the town of Hampton. Their story is to well known to every child in America to need recapitulation here.
>
> The introduction of [Africans] into the country as slaves was made at a time when only a few minds, here and there, had any true conception of the rights of individuals, or could put a fair interpretation upon that higher law which makes us our brothers' keepers; and the virgin soil and relaxing climate of the South made slavery so temptingly easy and profitable. In no part of the United States can the history of slavery, from its origin to its extinction, be more clearly traced than in Virginia. It is not too much to say that throughout the history of slavery in Virginia, there runs a strain of poetic justice which is absolutely dramatic, robbing facts of their dryness and interweaving the prosaic detail of life with the elements of tragedy. Nowhere has there been greater prosperity, nowhere has there been greater suffering, and many a page might be filled with the record of the changes which two centuries of slavery had wrought.
>
> In 1861 the curse which was the cause of the blighted prosperity, not of one town only, but of the whole South, had fallen, and when the first cargo of slaves landed within a few miles of Hampton, it was as if men's eyes were there after blinded to the light of God's Truth for from that hapless day, each year but added to the incubus until relief could only come through fire and sword. Viewed in the light of later events, this landing of the first slaves at Hampton ranks as one of the strange

coincidences of fate; for here upon the spot where they tasted first the bitterness of slavery, they also attained to the privileges of freedmen, the famous order which made them "contraband of war," and thereby virtually gave them their freedom having been issued by General Benjamin F. Butler, from the camp at Fortress Monroe, in May, 1861.

As the months went by a greater change than all drew near; and when in the early summer of 1861, troops of blacks came pouring in from the interior of the state and the northern counties of North Carolina. How these people lived was and still is a mystery. However, all through that long first summer of the war, we find occasional evidence that these new-born children of freedom were not altogether forgotten; in October of the same year, we know that organized work was begun among them. This work was initiated by the officers of the American Missionary Association, who in August, 1861, sent down as a missionary to the freedmen, the Rev. C. L. Lockwood, his way having been opened for him by an official correspondence and interviews with the assistant Secretary of War and Generals Butler and Wool; all of whom heartily approved of the enterprise and offered him cordial cooperation.

This was certainly encouraging and he reports that among the contrabands he finds little intemperance and a hunger for books among those who can read, which is most gratifying. He first opened a Sunday school in the deserted mansion of U. S. President Tyler; in Hampton. On November 17th, the first day-school was opened with 20 scholars and a colored teacher, Mrs. Mary K. Peake, who before the war, being free herself, had privately instructed many of her people who were still enslaved, in the Bethel AME Church, until the burning of Hampton. In April 1862, Mary Peake died having literally laid down her life for here people, for whom she labored beyond her strength until death lifted her self-imposed burden.

By the end of October, Mr. Lockwood started four other schools all taught by colored teachers, one of the being held in the Tyler house, one at Wood's Mill and at the Seminary, preaching services were held regularly. In 1862, Captain Charles B. Wilder was appointed superintendent of contrabands, and soon afterwards the courthouse in Hampton, whose walls had survived the fire, was fitted up for a graded school. The number of refugees and the number of schools continued to increase until in December 1864 there were in Hampton and vicinity five schools with seven hundred pupils and teachers. In 1865 the teachers were still living in the Tyler house, where at that time an industrial school was being carried on for women and girls.

In the same year the courthouse reverted to the county authorities and the graded school for freedmen was transferred to the Lincoln School, which had been built of old hospital wards. In this year also, the large school for the Contrabands built by General Butler in 1863 was handed over to the American Missionary Association by General Howard. A year later there were fourteen hundred pupils in the day schools, and three hundred in the night schools. In April 1867, there were twenty-four workers in and around Hampton. The question of the advisability of establishing a training school for colored teachers in this vicinity now began to be discussed in the American Missionary Magazine. In March 1866, Captain Wilder was succeeded by General S.C. Armstrong and superintendent of the contrabands and officer in charge of the Freedmen's Bureau.

One

Principals, Presidents, and Distinguished Faculty

In *Education for Life* by Gen. Samuel Chapman Armstrong, Helen Ludlow wrote the following biography about the general:

Samuel Chapman Armstrong was born on January 30, 1839, in a missionary home on the mountain slope of Maui, Hawaii. His parents, Richard Armstrong of Pennsylvania and Clarissa Chapman of Massachusetts were missionaries in Hawaii as representatives of the American Board from 1831 until 1847, when Dr. Armstrong was appointed Hawaiian Minister of Public Instruction. When he took charge of, and in part built up, the five hundred Hawaiian free schools and some of the higher education work, until his death in 1860. Armstrong's father holding this position gave him the perfect opportunity to observe two systems of educational work: the Lahaina-luna Seminary (government) for young men, where, with manual labor, mathematics, and other higher branches were taught; and the Hilo Boarding and Manual Labor School (missionary) for boys, on a simpler basis. As a rule the former turned out more brilliant, the latter less advanced but more solid men.

In 1860, after the death of his father he returned to the main land where he entered Williams College, in Massachusetts. Here he completed his education under Dr. Mark Hopkins. He said of his teacher, "Whatever good teaching I may have done has been Mark Hopkins teaching through me." In 1862, he graduated with honors and joined the Union Army with a captain's commission. He was put in charge of a colored troop and he worked his way through the ranks to be promoted to the rank of Brevet Brigadier General. Armstrong observed the colored troops tidiness, their devotion to their duty and their leaders, their dash and daring in battle, and their ambition to improve often studying their spelling books under fire showed him that slavery was a false though, for the time being, doubtless an educative condition, and that they deserved as good a chance as any people. In 1866, Armstrong was appointed by General O.O. Howard, as Commissioner of the Freedmen's Bureau, in charge of 10 counties in Eastern Virginia, with the Headquarters in Hampton, the great "contraband" camp, to manage Freedmen affairs and adjust if possible the relations of the races.

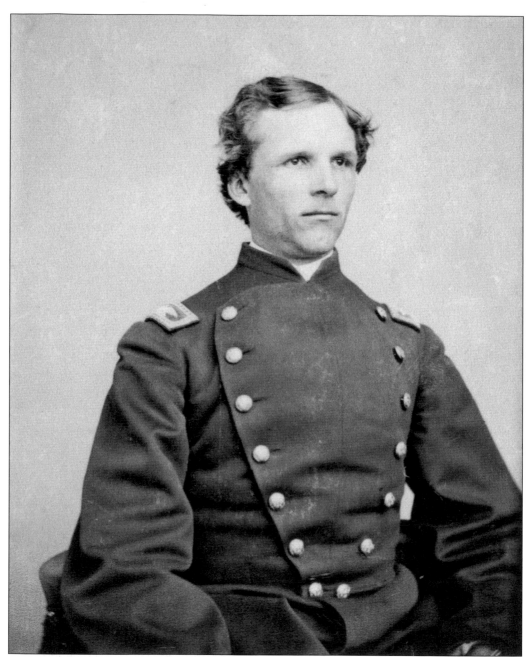

In Hampton, Samuel Chapman Armstrong found himself in charge of thousands of black squatters and disbanded black Confederate soldiers returning to their families. It took nearly two years for him to settle the disenfranchised contrabands. Many of the squatters returned to their plantations on government passes and 30 days of rations. In 1867, he appealed to the American Missionary Association (AMA), through a magazine article, for the need of a normal school. His suggestion met with approval, land for the school was purchased, and the school was organized under a charter that was granted by Elizabeth City County on September 21, 1868, and later was incorporated under an act of the Virginia General Assembly, which was approved on June 4, 1870. (Courtesy of HathiTrust.)

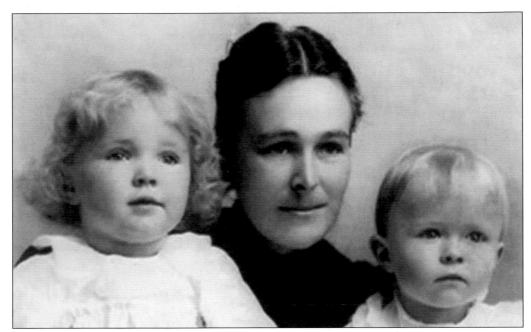

Armstrong married Emma Jean Walker of Stockbridge, Massachusetts, and was a devoted husband and father. Emma and Samuel Armstrong had two children, Louise Hopkins Armstrong and Edith Hull Armstrong; however, soon after the birth of the second child, Emma became ill and died. On September 10, 1890, he married Mary Alice Ford, a teacher at Hampton. Together, they had two children, Margret Marshall Armstrong and David William Armstrong, pictured. (Courtesy of Margie Emmons.)

While on a speaking engagement, Samuel Armstrong became stricken with agonizing paroxysms and paralysis. "Cast down, but not destroyed," he used a wheelchair while giving tours of the school and touring for donations. His body succumbed to the disease on May 11, 1893. (Courtesy of HathiTrust.)

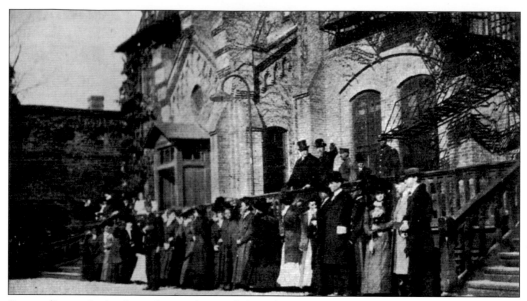

Succeeding principals and presidents of the school include the following: Rebecca Bacon (1869), Mary Mackie (1872), Dr. Hollis Burke Frissell (1893–1917), Rev. Dr. James Edward Gregg (1918–1929), Dr. George Perley Phenix (1930), Arthur Howe (1930–1940), Dr. Malcolm Shaw MacLean (1940–1943), Dr. Ralph P. Bridgman (1944–1948), Dr. Alonzo G. Moron (1949–1959), Dr. Jerome Heartwell Holland (1960–1970), Dr. Roy Davage Hudson (1970–1976), Dr. Carl McClellan Hill (1976–1978), and Dr. William Harvey (current president). Pictured are President Taft and Dr. Frissell in front of Virginia Hall. (Courtesy of HathiTrust.)

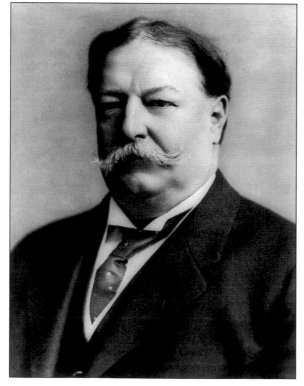

William Taft served as president of the Board of Trustees of Hampton University from 1909 until 1930. During that time, he also served as president of the United States and chief justice of the United States. Other members of the board of trustees included Arthur Custiss James (1893–1941), Henry Wilder Foote, Frank W. Darling, Hon. W. Cameron Forbes, James E.C. Norris, Clarence "Jap" Curry, and Dr. Isai Urasa, to name a few. (Courtesy of Library of Congress.)

Two

CAMPUS SCENES

In *Hampton and Its Students* by Mary Armstrong and Helen Ludlow, Hampton's campus was described as follows:

Just at the mouth of the Chesapeake Bay, where one of its numerous tributary creeks opens into the broad harbor of the Hampton Roads, stands a little village, scattered along the western shore of the creek, long ago there stood half-ruined houses and low white cabins irregularly clustered upon the level green meadows down to the very water's edge. The back country through which the creek wanders for the few miles of its course, and the shore itself, are flat and monotonous, expect for the brilliant coloring and golden, semi-tropical sunshine which for eight months in the year redeem the landscape from the latter charge. But the changeful beauty of the shore, even when at its climax in the fresh spring months, can bear no comparison with the eternal beauty of the sea, which stretching far on either hand, offers by day and night, in calm and storm, new glories and beautiful, strange surprises of color and sound and motion.

Here in this scenic location is where the school property has a frontage of nearly half a mile on Hampton River, a small navigable arm of Hampton Roads, and extends back from the water about the same distance. Directly across the river lies the city of Hampton, Newport News is seven miles to the west, Fort Monroe aka Old Point Comfort is two and a half miles to the east, and Norfolk but fifteen miles distant across the waters of Hampton Roads. General Armstrong chose the land because it was centered in a place that was easily accessible to the students. The school opened April 1, 1868 with 15 students and Miss Cecilia Williams and Miss Phebe Williams as teachers.

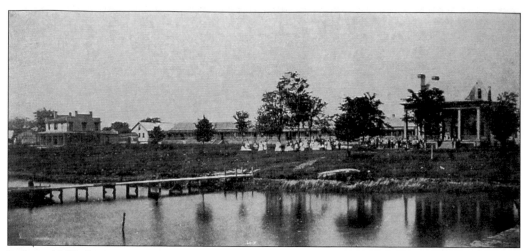

In June 1867, the American Missionary Association (AMA) approved the purchase of the 125-acre Camp Hamilton, which was formerly the Woods family's plantation, known as Little Scotland. Armstrong selected the site for its natural beauty and healthiness, its accessibility to the water, and the black population that surrounded the area. With a donation of $10,000, land was purchased on October 1, 1867. (Courtesy of HathiTrust.)

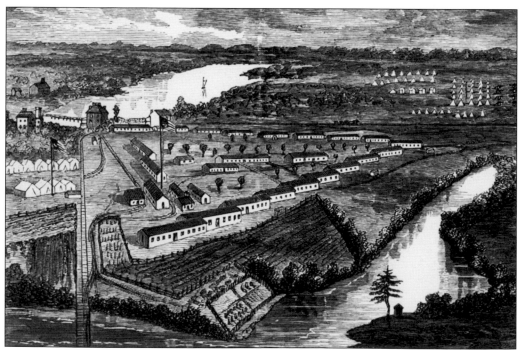

The purchase included two other lots of little value, which had 40 acres and $12,000 worth of available buildings, including a mansion, flour mill, and hospital barracks; the total cost was $19,000. In March 1872, the State of Virginia appropriated 100,000 acres of public land, known as Segar Farm. (Courtesy of HathiTrust.)

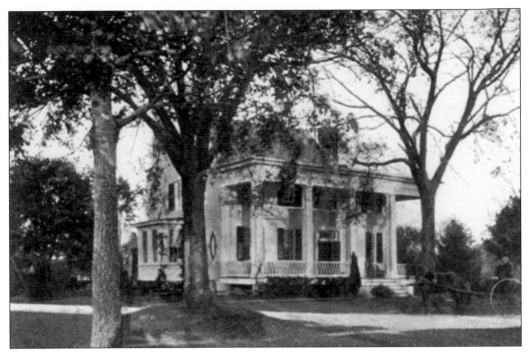

The Principal's Mansion is the oldest structure on the grounds. Prior to the war, it was the plantation's mansion; however, it was abandoned and then confiscated and used as a campsite for soldiers. Later, it was occupied by missionary teachers of the contrabands and was made into the headquarters of the Freedmen's Bureau for the Hampton District. (Courtesy of Library of Congress.)

In 1901, it became necessary to remodel the Principal's Mansion. The student tradesmen did the necessary tearing down and rebuilding. They preserved, in great part, its old Colonial-style architecture, but they also made some additions and necessary repairs. The students were happy to have the opportunity to practice their trade on such a historic building. Today, it is known as the President's Mansion. (Courtesy of HathiTrust.)

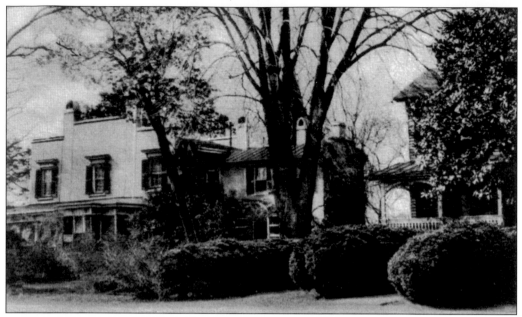

After the war, all that remained of the flour mill were four walls of brick. School instructors created drawings for the renovation of the building. Donations came from the widow of Stephen Griggs. The building was named in their honor during a tour of the campus when she noticed that, after donating $10,000, there was nothing that bared her name, and so Armstrong pointed to the building and proclaimed it Griggs Hall. (Courtesy of Byron Puryear.)

This red structure located at the front of the campus next to the Emancipation Oak was believed to be where Mary Peake taught. However, according to a native of the campus, the one-story building was moved from behind a home that was once on campus. Reverend Lockwood described the original "Red Cottage" as being two stories and habitable.

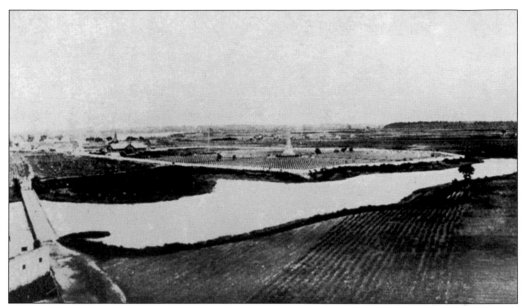

National Cemetery is situated on the southeastern side of the school grounds. According to *Visitors' Hand Book of Old Point Comfort, Va., and Vicinity* by Charles Wyllys Betts, it "is an irregular figure, of many sides, six of them being right lines, the balance following the windings of the inlet . . . It contained 11.61 acres of level land, and was purchased by the United States, in 1867, for the sum of $6,306. It is enclosed in a rubble stone wall, laid in mortar, and covered by rough coping." (Courtesy of HathiTrust.)

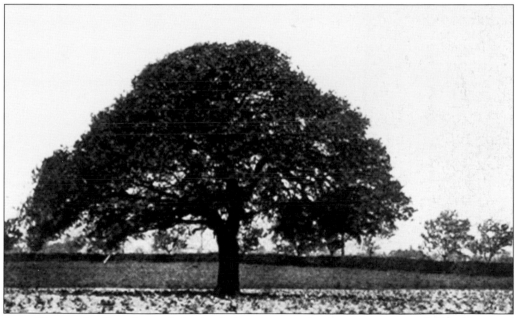

A seedling at the founding of Elizabeth City County, the Emancipation Oak has witnessed major events in the history of Virginia. It stood proud through the American Revolution, it served as the gathering place for thousands of contraband slaves to hear the Emancipation Proclamation; and it provided shade to students of Mary Peake. The tree still stands today and is visited by tourists from around the world. (Courtesy of HathiTrust.)

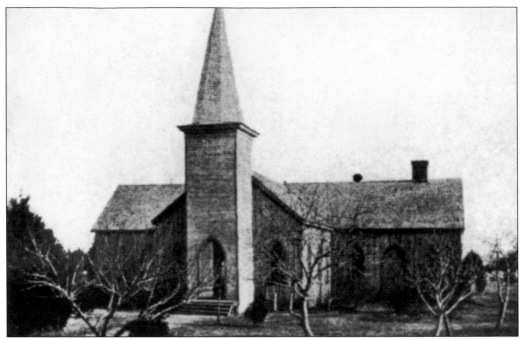

Located on the grounds of the National Cemetery, Bethesda Chapel was a wood-frame structure, built by Union soldiers during the Civil War. The chapel was under the direction of well-known author Rev. E.P. Roe. Members of First Presbyterian Church met here; however, they refused to worship with students. So, Armstrong approved the founding of the Church of Christ. (Courtesy of HathiTrust.)

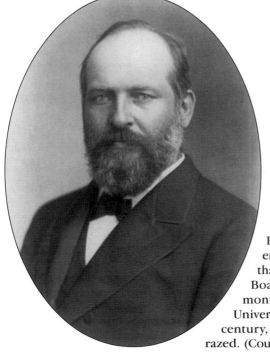

Bethesda Chapel hosted many speaking engagements, and the most memorable was that of Pres. James Garfield, president of the Board of Trustees of Hampton University. A month after his June 1881 visit to Hampton University, he was assassinated. By the late 19th century, the chapel began to show wear and was razed. (Courtesy of Library of Congress.)

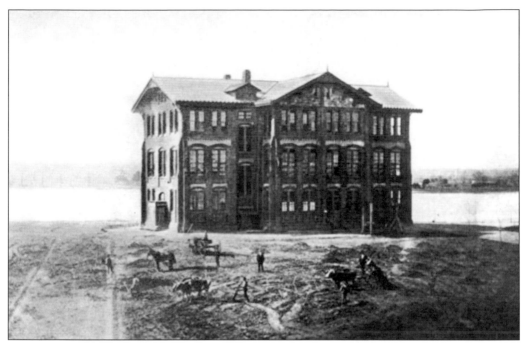

Academic Hall was the first building constructed on the school grounds. It was designed by Richard Morris Hunt. Under the supervision of Albert Howe and foreman Charles D. Cake, students constructed the building. (Courtesy of Library of Congress.)

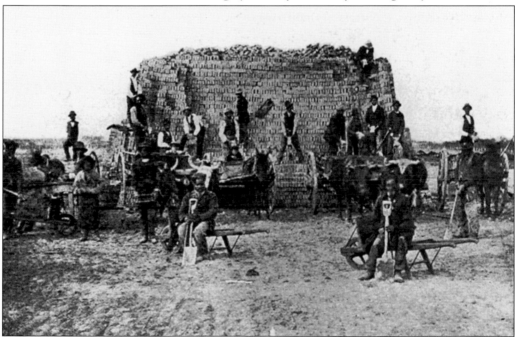

Pictured is the brick kiln used to make the bricks for the construction of Academic Hall and several other buildings on campus. Edward Jones, a black man in the township of Hampton, was selected by Arthur Howe to make the bricks for the buildings. (Courtesy of Library of Congress.)

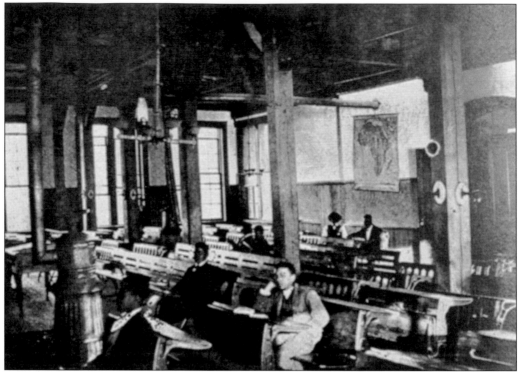

This building housed a dormitory for male students, a library and museum, recitation rooms, and a 400-person assembly room. The assembly room was large and very beautiful. The ceiling had a mosaic of southern yellow pine, which was either stained or in its natural color, and the walls used the same wood for wainscoting. (Courtesy of Library of Congress.)

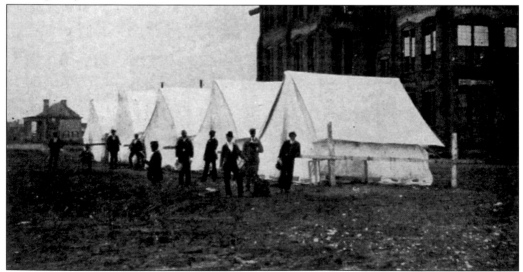

By 1872, the school was overcrowded with male students. Unwilling to turn anyone away, students were housed in the Bethesda Chapel and hospital tents left from the war. Armstrong taught the male students how to rough it and often went to the tents and shared stories of tent living from his war days. (Courtesy of HathiTrust.)

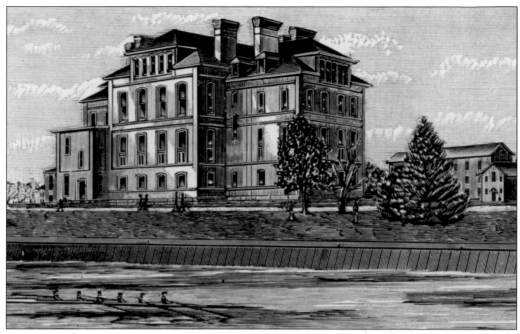

On November 9, 1879, Academic Hall was destroyed by fire. Artifacts from the founding of the school were destroyed in the small museum. Richard Morris Hunt was commissioned to design the new building. Armstrong instructed him to design a simple building with little ornamentation. Hunt designed a 3.5-story building with a cruciform plan, hipped roof, broad hipped dormers, and segmented arched openings. The new building opened in 1881 and was renamed Carl Schurz Hall in 1915. (Courtesy of HathiTrust.)

Dormitory rooms inside Academic Hall were simply furnished with beds, chairs, and wardrobes. Students were given books and art by Northern benefactors. Male and female students made bed linens and furniture on campus. (Courtesy of HathiTrust.)

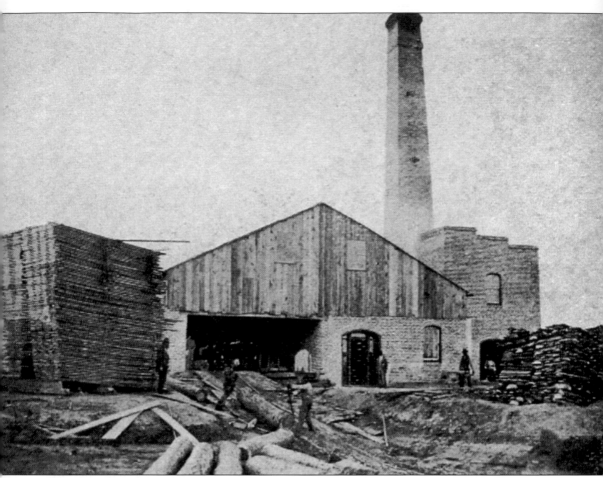

The first sawmill was erected in 1874, when General Armstrong recommended the following: "That the material of the barracks [old hospital barracks that once served the sick and wounded at Camp Hamilton], formerly used as the girls' quarters, be used in building a shop for students who are learning trades." Armstrong insisted that it be built to serve two purposes, to save the school money from costly outsourcing of lumber and to serve as a shop for trade school students. (Courtesy of HathiTrust.)

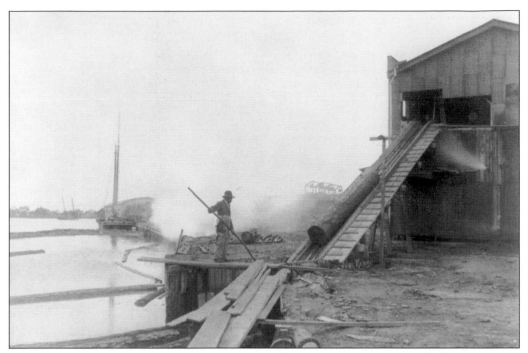

Here, students were introduced to the duties of log haulers, sawyers, edger, turner, and lumber pilers. They also learned how to operate the dry kiln for different types of wood. (Courtesy of Library of Congress.)

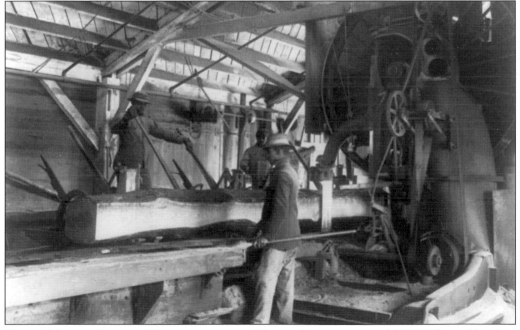

Pictured is a student working a power saw. The students processed 15,000 feet of lumber per day. The program allowed for 15 to 20 students to work one year at 10 hours per week. If they showed great promise, they were then allowed to enter the woodworking apprenticeship program for two years. (Courtesy of Library of Congress.)

On the left is Uncle Tom's Cabin; it is the earliest known kitchen on the campus. The building was named for the cook. On the right was the Oyster House Restaurant, owned by Captain Tennis. When confronted by General Magruder to remove the Union flag, he objected. After the burning of Hampton, his Union flag could be seen from the other side of the creek waving in the air, giving hope to all. (Courtesy of Library of Congress.)

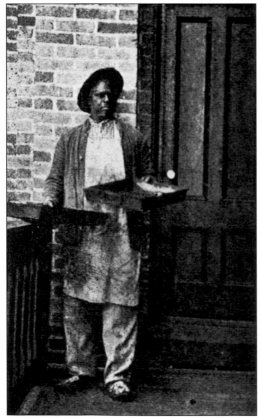

Pictured is the school's first cook, Tom, for whom the kitchen was affectionately named. He was featured in *Harper's Weekly* and described as having Romanesque features. His favorite foods included oyster soup, cornbread, and strawberry pie. According to the *Harper's Weekly* reporter, Tom did not like having his picture taken. This is the only known picture of Tom. (Courtesy of Library of Congress.)

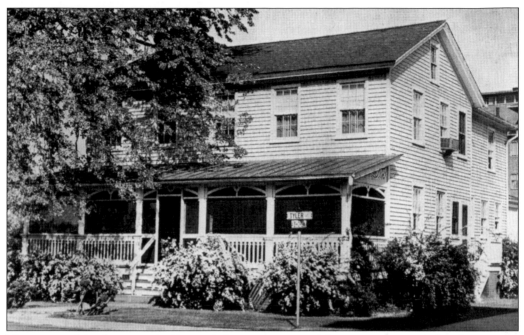

The original kitchen, Uncle Tom's Cabin, was a wood-frame structure with a basement, pine floors, and slate roof. By the 1950s, it was in need of renovation. The changes to the building included a second floor, live-in attic, and a back portion that housed five apartments for faculty and staff. (Courtesy of Byron N. Puryear.)

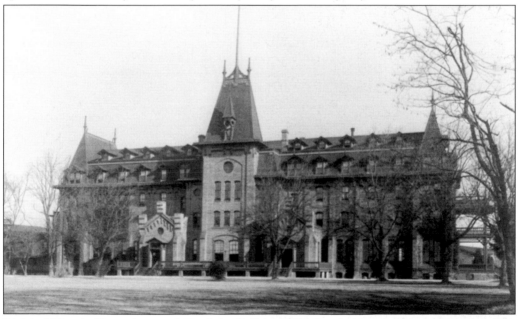

Richard Morris Hunt designed Virginia Hall in 1873. He designed an imposing 4.5-story brick structure, with picturesque High Victorian exterior. At its completion in 1874, the dormitory was built with between 800,000 to 1 million bricks, which were all made and laid by Hampton students. The building formerly opened on June 11, 1878. (Courtesy of Library of Congress.)

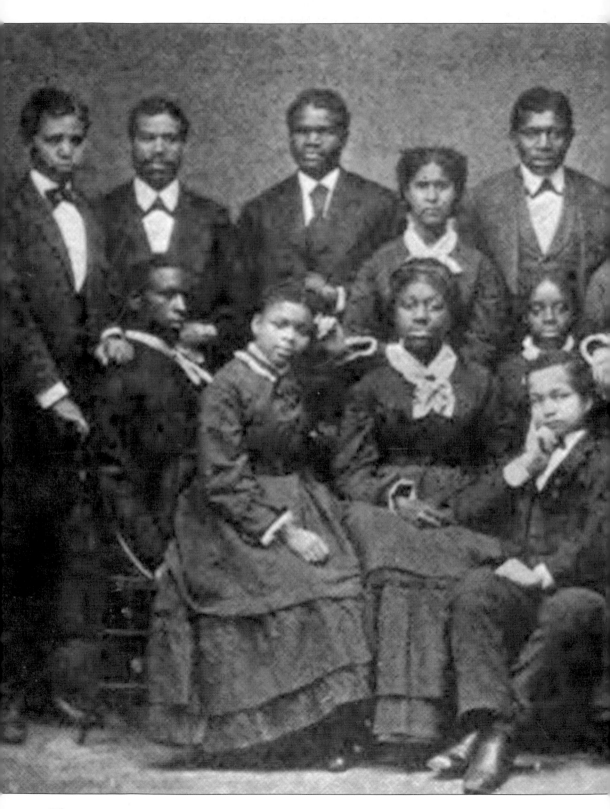

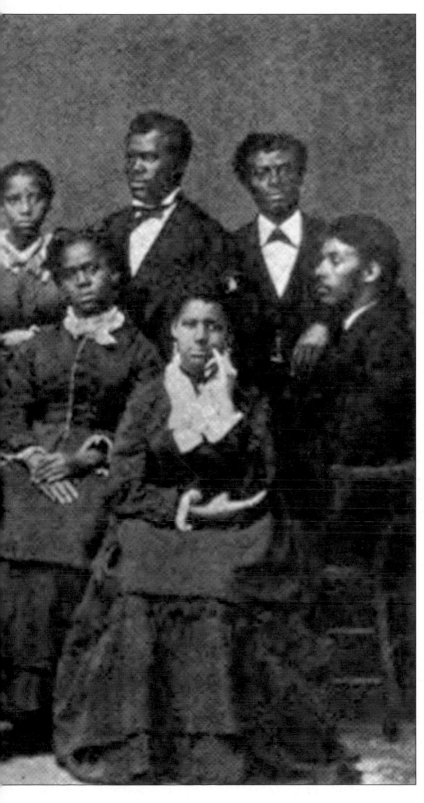

Virginia Hall was completed largely through the efforts of these students known as the "Hampton Students." This group of singers was formed by the renowned Thomas P. Fenner of Providence, Rhode Island, in 1872. After three years of sing campaigns, they raised money for the building of Virginia Hall. So impressed were the donors in Boston, Massachusetts, that the school was guaranteed the funding for the completion of the walls and roof with a gift of $10,000. Members of the Hampton Students were leading soprano Carrie Thomas; first and second sopranos Alice Ferribee, Rachel Eliott, Lucy Leary, and Mary Norwood; altos Maria Mallette and Sallie Davis; first tenors Joseph Mebane, Hutchins Inge, Whit Williams, and James C. Dungee; second tenors William G. Catus and J.B. Towe; first basses Jason H. Bailey and Robert H. Hamilton; and second basses James M. Waddy and John Hold. (Courtesy of HathiTrust)

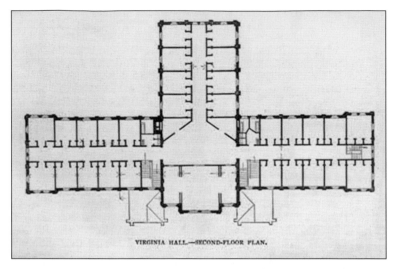

VIRGINIA HALL.—SECOND-FLOOR PLAN.

Virginia Hall held several departments. The first floor contained student-teacher dining rooms, and the second floor housed teacher-student parlors. There was also a chapel dedicated to Whittin; it was later used as a girls' study hall that could accommodate 400 people. (Courtesy of Library of Congress.)

The third and fourth floors contained the rooms of the teachers and black female students. Girls did all the housework for their building. School officers inspected all dormitories on a weekly basis. Laundry for over 1,000 persons, totaling 25,000 pieces, was washed every week. The basement housed a bakery and commissary. (Courtesy of Library of Congress.)

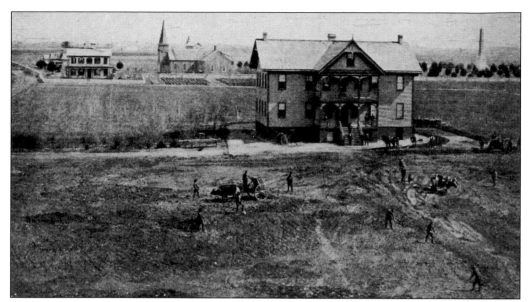

Graves Cottage was built in 1874 to accommodate the male students who where were either sleeping in tents or in the Bethesda Chapel due to the lack of housing. The building cost $6,000 to be constructed, and the students made the furnishings. Booker T. Washington was living in a tent when he was assigned to the cottage soon after it was built. After 40 years of use, the building was not repairable and was razed. (Courtesy of Library of Congress.)

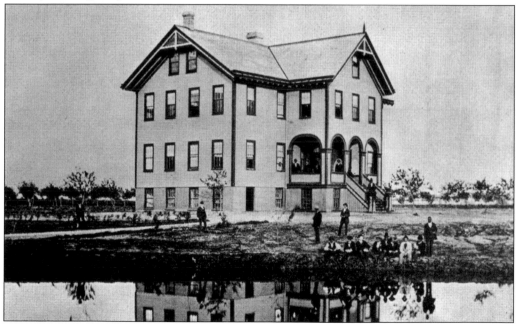

The second boys' dormitory, Marquand Cottage, was funded by Fredric L. Marquand and was constructed in 1876. In the 1930s, the first floor was converted into a private dining room and kitchen for faculty, and it was later converted into a restaurant for students in 1942. Eventually, Marquand Cottage was razed to make room for Harkness Hall. (Courtesy of Byron N. Puryear.)

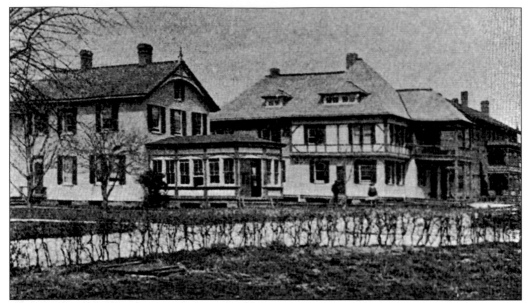

The Treasury Building was erected in 1890 and was a gift from Elbert B. Monroe, who donated $7,550. The building contained the treasurer's office, accounting department, the commandant's office, and guest rooms. Later, the building was renovated to contain apartments for faculty and staff. (Courtesy of HathiTrust.)

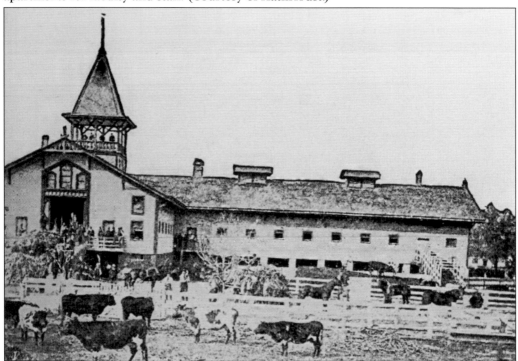

Whipple Barn was built in 1873 and was named for George Whipple, a charter founder and major benefactor to the school. The care of the barn and the maintenance of the farm were under the employ of all of the students at the school under the management of Albert Howe. (Courtesy of Byron N. Puryear.)

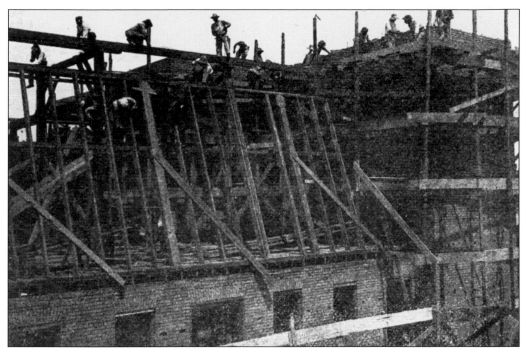

In 1904, the barn burned in a fire, but soon, money was raised for a new barn, built by students in 1906. The Victorian-style structure was designed as a farmhouse and dairy barn; its construction cost was $32,440. (Courtesy of HathiTrust.)

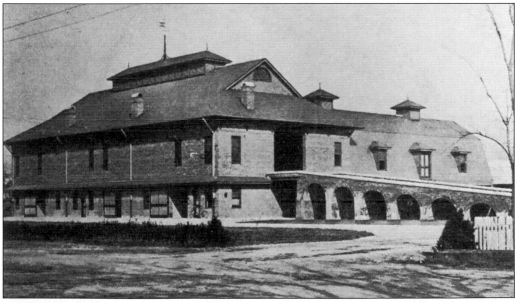

Later, it was converted to headquarters for the Reserve Officers Training Corps (ROTC) at Hampton. It housed offices and space for equipment storage. In 1965, the ROTC program moved out the building, and it was then used primarily for storage for the purchasing and roads and grounds departments. Today, this building houses the campus police department, admissions, financial aid, and other administrative offices. (Courtesy of HathiTrust.)

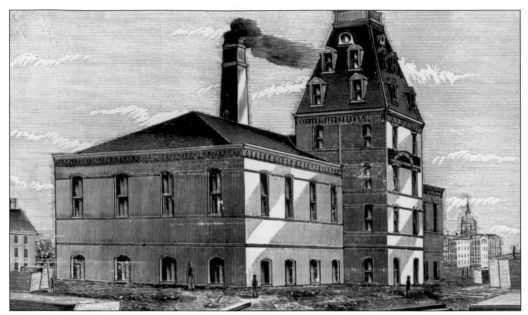

Construction on Huntington Industrial Works began in 1878; it was a $15,000 gift from Collis P. Huntington. At its completion, the 140-by-50-foot building was a two-story frame structure on a brick basement, consisting of 200,000 bricks made on campus. By August 1879, the building was open and ready for operation. (Courtesy of HathiTrust.)

The building included a new 60-horsepowered engine with a boiler, a gift from George H. Corliss of Providence, Rhode Island. There was a sawmill as well as a woodworking area. The building also housed an edger, planer and matcher, lathe machine, small saws, and other carpentry equipment. (Courtesy of Library of Congress.)

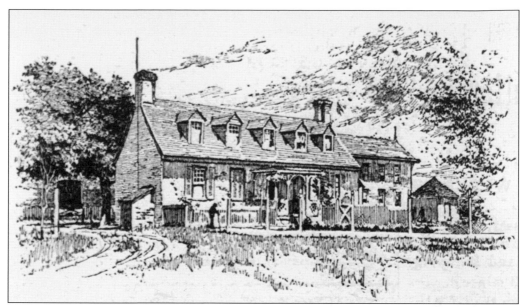

In 1878, Shellbanks, a farm, was purchased as a gift from Mary Hemenway of Boston. It supplied work for students and large supplies for school consumption. Though the farm was located six miles away from the campus, it served as an educational facility by providing classrooms, a dormitory, and an instructional staff. Students worked the farm during the day and attended classes at night. (Courtesy of HathiTrust.)

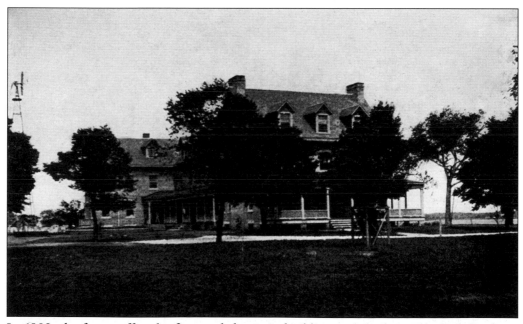

In 1902, the farm suffered a fire, and the main building and the barns burned. Students ran out to save the livestock and equipment. In 1903, George Foster Peabody of New York provided a donation for the dairy barn to be rebuilt. In the 1950s, Shellbanks was sold to Langley Air Force Base, and the farmhouse was renovated for use as offices. (Courtesy of HathiTrust.)

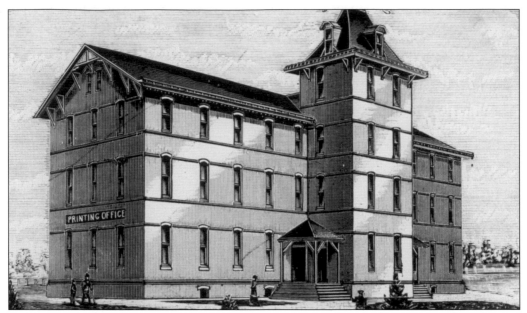

The three-story Stone Building contained the printing office, publication office, a knitting room, shoe factory, girls' industrial room, a tailoring establishment, a store, post office, and dormitories for young men. It was built between 1881 and 1882 and was a gift from Valeria Stone of Massachusetts. (Courtesy of HathiTrust.)

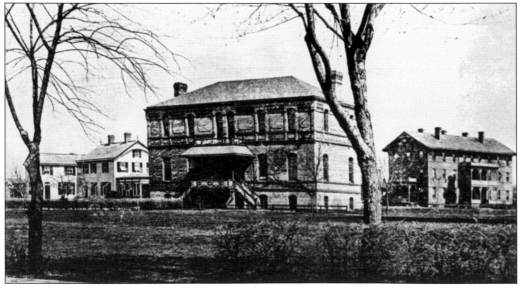

Built in 1882 at a cost of $10,650, Marshall Hall housed the library, museum, the principal's office, and treasurer's office. One section of the basement housed the infamous guardroom for unruly students. Trade school students constructed the building of brick, two stories in height with a basement. The building was named for the treasurer, Gen. J.F.B. Marshall. (Courtesy of Byron N. Puryear.)

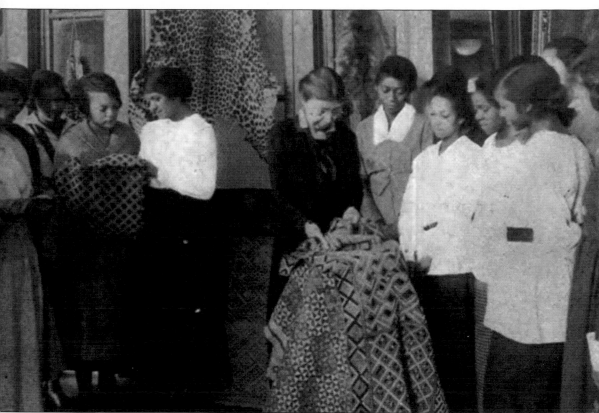

The school's museum started with a collection of items obtained by General Armstrong's parents in the Pacific Islands. Sadly, some things on display at the museum were destroyed by a fire in 1879; however, enough survived to help start the next museum collection in 1905. Alice M. Bacon visited Japan, and on her return, she brought back many old things. She loaned some of her Japanese artifacts to the museum, and at her death, she bequeath almost her entire collection. Also, Frances Curtis of Boston gave a Philippine collection of about 300 specially selected pieces. Articles from China, India, Egypt, Syria, Turkey, and other countries have been given from time to time; today, there is almost no country that is not represented. (Courtesy of HathiTrust.)

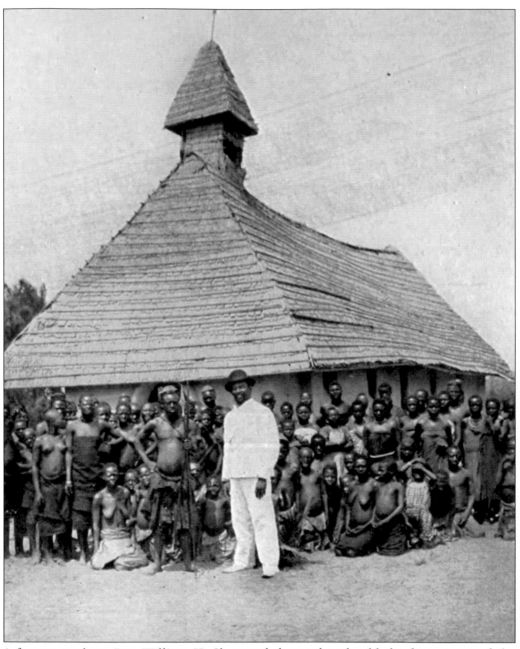

A former student, Rev. William H. Sheppard donated and sold the first pieces of the African collection to the university. He spent 20 years as a missionary among the tribes of the upper Congo. The large exhibits demanded increased space, and three rooms were added in 1918 to provide better accommodation, giving a floor space of about 5,400 square feet. Eventually, the African collection grew from 400 to over 2,000 articles. (Courtesy of HathiTrust.)

In 1882, General Armstrong announced that Moses Pierce had offered $4,000 for a 60-by-40-foot, two-story brick workshop, in which a bone mill and gristmill could be placed to great advantage. The building was completed in 1883. (Courtesy of Byron N. Puryear.)

Construction of the Marquand Gymnasium began in 1884 with a gift from Frederick Marquand. The Victorian-styled building was designed and constructed by trade school students and was located a block away from the shoreline. The building provided a gym, locker rooms, and facilities for physical education. The building was completed in 1885 with locker rooms. In 1903, the building was moved to the area near the cemetery, and renovations were made to the structure totaling $14,405. (Courtesy of Byron N. Puryear.)

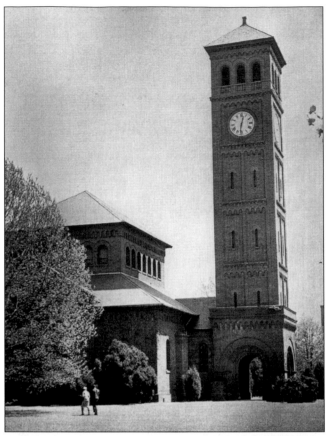

Marquand Memorial Chapel was the gift of the Frederick L. Marquand estate through E.B. Monroe, president of the school's board of trustees, and his wife. Dr. Mark Hopkins dedicated it in May 1886. The redbrick Italian Romanesque–style church seats 1,000 people. It has a 127-foot-tall square tower, which houses bells and a clock. (Courtesy of Byron N. Puryear.)

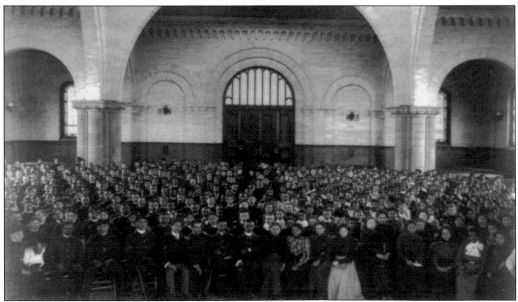

Here, students gather inside the Marquand Memorial Chapel. The sanctuary's walls are made of cream-colored brick. The pews were made by trade school students. (Courtesy of Library of Congress.)

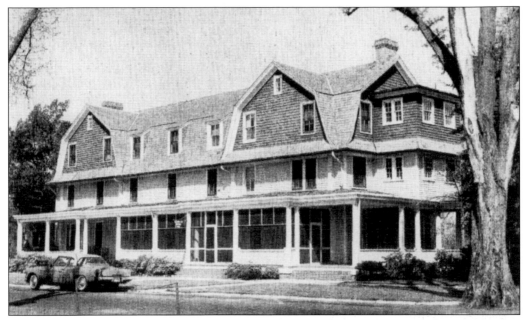

Holly Tree Inn was constructed in 1888, costing $1,900. The architecture was American Colonial, and the building was designed as a twin to the Abby May House. The first floor housed offices, two small living rooms, a kitchen, and a faculty dining room. The second and third floors were used as housing for unmarried faculty members. (Courtesy of Byron N. Puryear.)

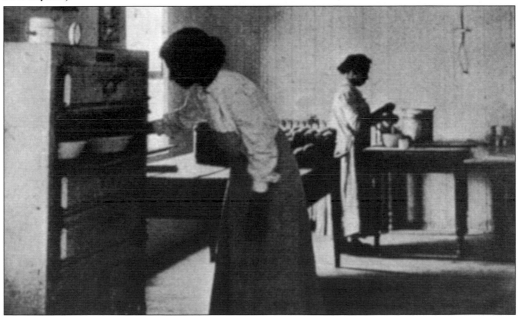

Pictured is the kitchen of the Holly Tree Inn where faculty, staff, students, and visitors still gather to enjoy the fine dining. In 1957, two years after her daring efforts with the civil rights movement, Rosa Parks moved to Hampton and worked in the Holly Tree Inn as a hostess. The Holly Tree Inn has been known for its many Southern dishes. (Courtesy of HathiTrust.)

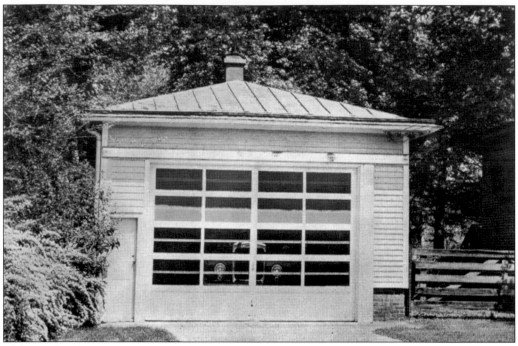

The firehouse was located next to the Wigwam Building; it was a one-story garage on a brick foundation with a metal roof. A small office was located in the back of the building, and a fire chief was later hired to oversee the campus. The structure was heated with steam heat, as were the other buildings, which helped to maintain the condition of the fire engine for many years. (Courtesy of Byron N. Puryear.)

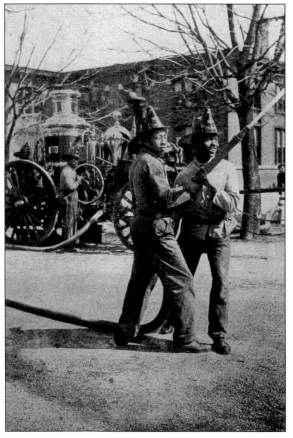

After experiencing a couple of fires and finding manual methods of firefighting were not working, Armstrong began the firefighter department at the school. A fire engine was purchased, and students were trained to use the equipment. When there were fires in the Hampton Township, the school was called upon to help extinguish them. (Courtesy of HathiTrust.)

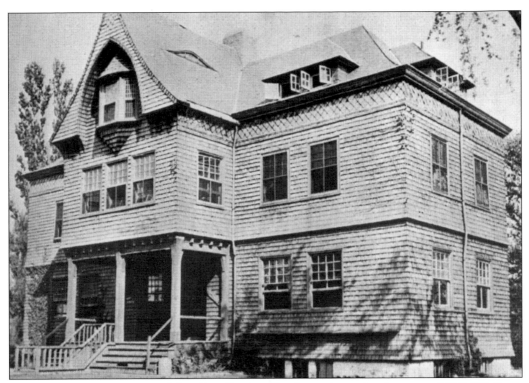

In 1890, Armstrong secured funding from a Northern donor in the sum of $21,693 for a science building to house biology and physiology. Students built the three-story wood-frame structure. The third floor housed a boys' dormitory. In the mid-1900s, the building was used for the music department and had 10 soundproof piano practice rooms, 6 classrooms with seating capacity for 150 students, and offices for the music department. (Courtesy of Byron N. Puryear.)

In 1894, the Abby May House opened for domestic science classes. Female students resided in the home in three-month intervals while receiving practical training in domestic science. By 1898, housing was needed for female graduate students, and so the classes were moved to another site. Cooking class students were require to make meals and bread twice a week for the residences as a part of their grades. (Courtesy of Byron N. Puryear.)

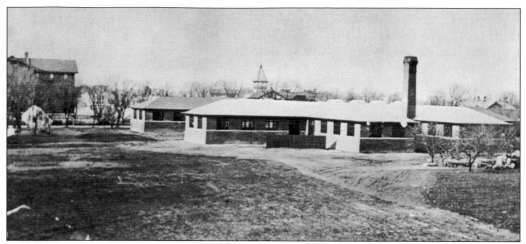

In 1896, Dr. Frissell suggested a one-story structure with 11 rooms for various trades be erected to replace the 1874 trade building. (Courtesy of Byron N. Puryear.)

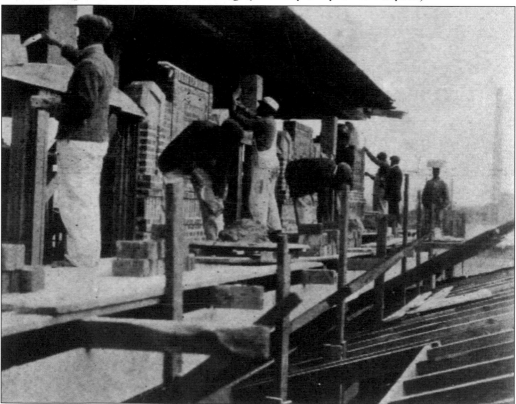

According to *Hampton Normal and Agricultural Institute: Its Evolution and Contribution to Education as a Federal Land-Grant College*, "When the school officers decided to add a second story to the trade-school building, the student tradesmen performed the laborious and difficult task of raising the heavy roof, with jacks which they had built, and of lowering the roof on the newly made walls." The students were devoted to finishing the interior of this large addition. The construction was so well organized and managed that it was done without interrupting instruction. (Courtesy of HathiTrust.)

In November 1896, the building was dedicated as the Armstrong-Slater Memorial Trade School. John F. Slater was a wealthy cotton manufacturer, who had donated $1 million to be used to uplift the emancipated slaves in the South by conferring on them the blessings of a Christian education. (Courtesy of Library of Congress.)

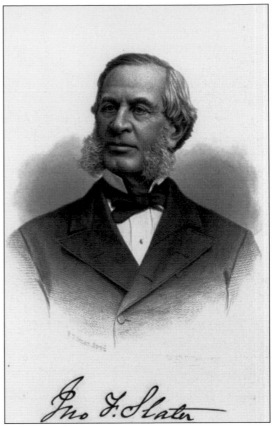

The Armstrong-Slater Building had a second story added, which doubled the original floor space. Its extreme length is 278 feet, and its width is 220 feet. Its floor space of 26,000 square feet is divided into 11 rooms for the various trades. (Courtesy of Byron N. Puryear.)

In 1898, the $50,000 domestic science and agricultural building was made possible by the gift of a friend. A total of 50 students constructed the two-story brick building and finished it in yellow pine. It was arranged with taste and simplicity, and each of its 18 large classrooms was specially suited to the purpose for which it was designed. (Courtesy of Byron N. Puryear.)

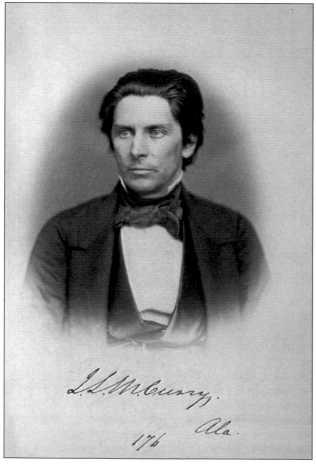

The building was named for Jabez Lamar Monroe Curry, an education reformer for all. He was a member of the Alabama House of Representatives, the US House of Representatives, and the First Confederate Congress. He worked with the Peabody Fund and the John F. Slater Fund to promote industrial education for the freedmen. (Courtesy of Library of Congress.)

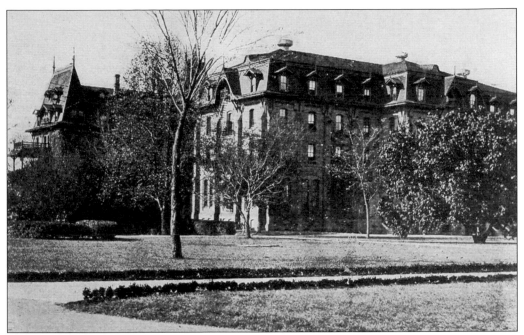

Cleveland Hall was a large brick addition to Virginia Hall; both halls were the same height. The 1,000-seat Cleveland Hall contained a chapel on the first floor. It was dedicated in January 1901 and named for philanthropist Charles Dexter Cleveland of Philadelphia. Its cost was defrayed by some of his former students. (Courtesy of Byron N. Puryear.)

When Cleveland Hall was built, the first floor was used as a chapel until 1918, when Ogden Hall opened. The chapel was then converted into a dining room for students. During this era, the students stood and sang the "Hampton Grace," which went as follows: "Thou art great and Thou art good, and we thank Thou for this food; by Thy hand must, we be fed; give us, Lord, our daily bread. Amen." (Courtesy of Byron N. Puryear.)

In 1903, Robert C. Ogden built the Mooring House for his daughter and son-in-law Helen and Alexander Purves, who was serving as treasurer of the school. The cost of construction was $15,847 for the 2.5-story home. The family deeded over the property to the school; the house was redesigned to host the museum and an apartment for the curator. (Courtesy of Library of Congress.)

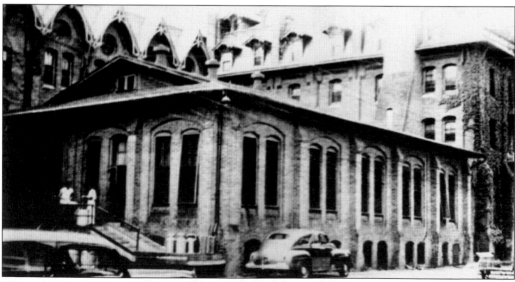

The student kitchen was built in 1904 at a cost of $19,938. This one-story building included a basement that housed the meat house. The kitchen provided food for Virginia Hall, Cleveland Hall, and the Holly Tree Inn. (Courtesy of Byron N. Puryear.)

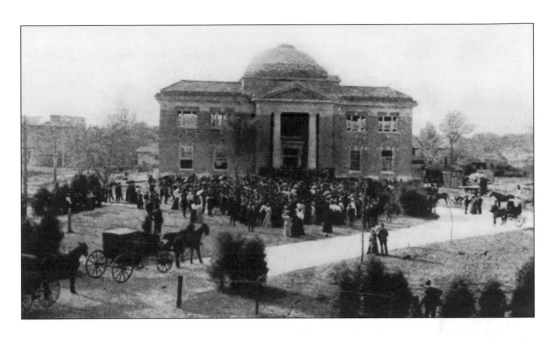

President Hadley of Yale University dedicated Huntington Memorial Library on April 28, 1903. Standing on the former site of the gymnasium and northeast of Cleveland Hall, the library is built of brick, with trimmings, a dome, and pillars of Indiana limestone. The interior is finished in yellow brick and Tennessee marble. Architects wanted the building to be as close to fireproof as possible. Its design is Colonial in style and of dignified proportions. The vestibule opens into a spacious rotunda, which accommodated 30,000 volumes. This building was used as a library until 1992. (Above, courtesy of HathiTrust; below, courtesy of Byron N. Puryear.)

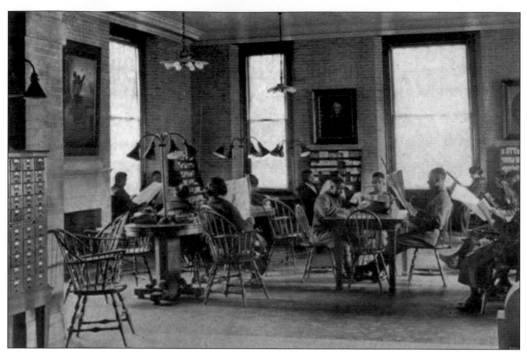

On the right as one entered was a large reading room with periodicals, and above it was a study or reference reading room of the same size. Upstairs on the left were large workrooms, and below it were offices and a room for exhibitions. (Courtesy of HathiTrust.)

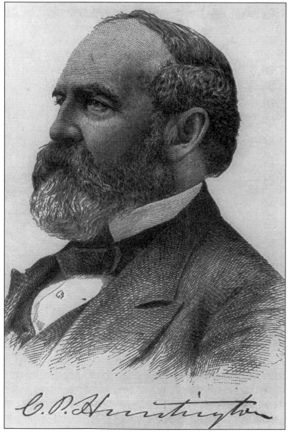

C. P. Huntington

Memorial Hall occupied the central space on the second floor of the library, and here, facing the landing, was a life-size portrait of the late Collis P. Huntington, the library's namesake. His wife and son had the building constructed in his memory. (Courtesy of Library of Congress.)

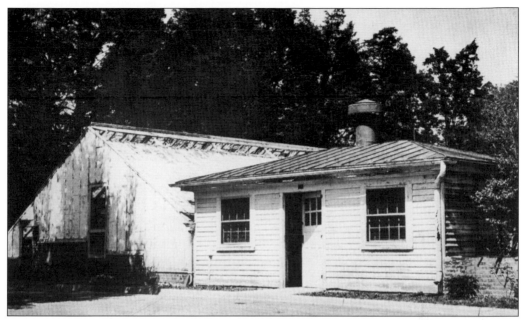

The greenhouses were truly the heart of the agricultural department, hence the reason why Ms. E.B. Monroe of Tarrytown, New York, donated the money in memory of her son. They were built in 1904 at a cost of $9,700. The greenhouses served as laboratories and, to some extent, as nurseries. In 1917, the greenhouses were razed, and new ones were built. (Courtesy of Byron N. Puryear.)

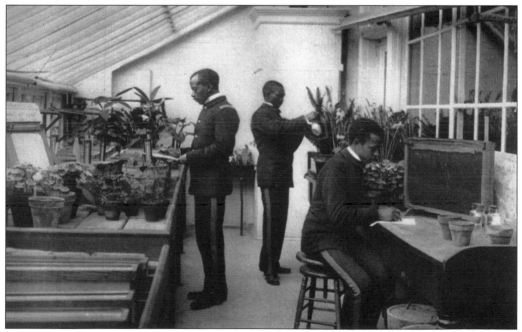

The greenhouses were used as laboratories for the agricultural students. Here, they studied year-round plants and flowering plants from around the world. Students were hired and paid to maintain the plants throughout the school year. Asa Simms was the last manager of the greenhouses. (Courtesy of HathiTrust.)

In 1913, trade school students began construction on Clarke Hall. The purpose of the building was to house the Young Men's Christian Association (YMCA). The beautifully detailed building houses the Wainwright Auditorium, which seats 300, and also contains a foyer, several committee rooms, four offices, a small kitchenette, and a balcony. The building was designed in a contemporary adaptation of Renaissance architecture. (Courtesy of HathiTrust.)

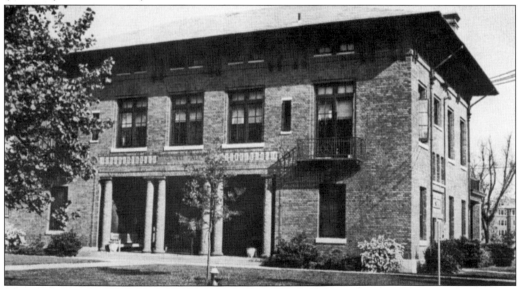

Clarke Hall was primarily used for activities of the YMCA, and Delia S. Clarke of New York gave it as a gift in memory of her husband, Charles Spears Clarke. It was the first black students' YMCA building in the United States. Wainwright Auditorium was named in memory of John H. Wainwright, famed basso in the Hampton Quartet for over 50 years. (Courtesy of HathiTrust.)

The growing school and museum collection necessitated the enlargement of Marshall Hall. Ludlow & Peabody, New York architects, drew up plans for the addition. After Marshall Hall was lowered four feet, six inches by outside contractors with the aid of 107 students, the work to add to the building began in August 1916. The new building was made of brick with two stories, a basement, an attic, and reinforced concrete floors. (Courtesy of HathiTrust.)

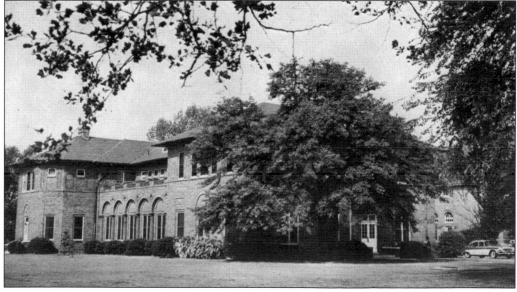

At its completion, the first floor had 23 offices and 2 vaults, and the second floor had a large museum and reception room, 7 offices, and a vault. The addition comprises of 330,000 bricks, 175 window frames, 13,000 feet of heart yellow pine flooring, and 104 oak-veneer doors and 14 that are kalemined (or metal) fireproof. The building was named for Gen. William Jackson Palmer. (Courtesy of Byron N. Puryear.)

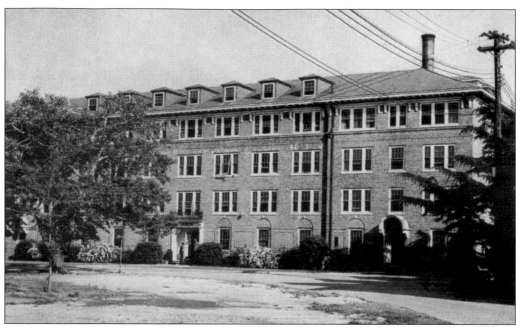

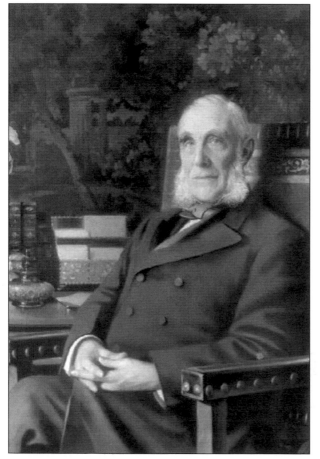

Ellen Curtiss James of New York gave Hampton Institute a sum of money for the construction of a four-story boys' dormitory, which would accommodate about 175 students, in memory of her husband, Daniel Willis James. Students did all the work on this $100,000 fireproof building, and it was completed in 1917. In 1920, the Winona School opened under Dorah M. Herrington, and it was held in a large room in the back of the dormitory. Winona School was an ungraded school for the children of white faculty members. (Courtesy of Byron N. Puryear.)

Pictured is Daniel Willis James. James was born in Liverpool, England, where his father was a prominent merchant. He became interested in the manufacture and importation of metals and became the best-known metal merchant of New York City. He was widely known in business but was deeply interested in education and philanthropic work. (Courtesy of Library of Congress.)

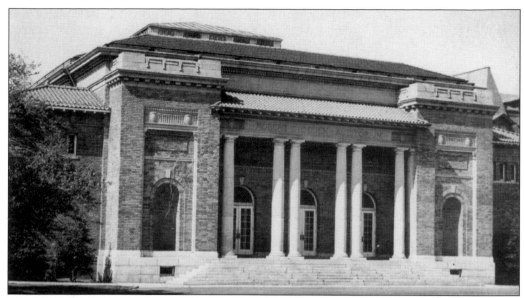

Built in 1918, Ogden Hall, with a seating capacity of 2,500, was designed by Ludlow & Peabody and was built at a cost of $200,000 by the Whitney Company of New York. (Courtesy of Byron N. Puryear.)

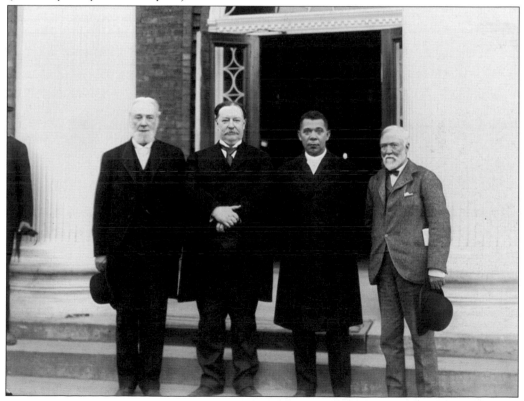

Ogden Hall, a beautiful auditorium, was erected as a national tribute to the memory of Robert Curtis Ogden of New York. Pictured are, from left to right, Ogden, President Taft, Booker T. Washington, and Andrew Carnegie. (Courtesy of Library of Congress.)

Monastery is a three-story brick structure with a basement, and it has stucco exterior walls. The building was constructed in 1926 by the trade students. The cost of construction was $44,149. The purpose of the building was to house college guests, faculty, and staff. As attendance grew, the building was eventually used to house students. (Courtesy of Byron N. Puryear.)

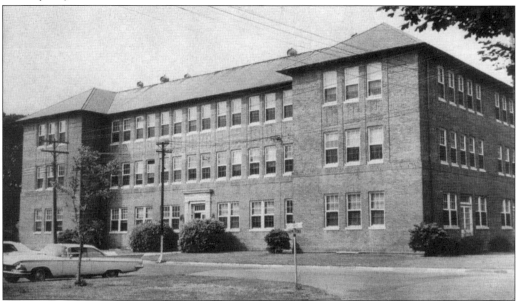

In 1928, trade students constructed Coleman DuPont Hall. Architects designed a 190-person auditorium on the first floor and placed classrooms and laboratories for natural sciences, biology, mathematics, chemistry, and physics on the other two floors. (Courtesy of Byron N. Puryear.)

Thomas Coleman DuPont of Wilmington, Delaware, pictured, donated $154,538 for the construction of the science department's building. DuPont reorganized his family's explosive business into a large, centrally managed chemical manufacturer that is a multibillion-dollar corporation today. (Courtesy of Library of Congress.)

Constructed in 1931 by trade school students, Bemis Laboratories was named for Alan Bemis, a member of the board of trustees. The two-story wings and three-story body housed the maintenance department's office, metalworking shop, bricklaying laboratory, the building construction department, architecture department, ceramics laboratory, classrooms, and a small auditorium. (Courtesy of Byron N. Puryear.)

Mrs. Clarence Kelsey donated $126,464 for the construction of Kelsey Hall, a female dormitory, in memory of her husband, who served as the vice chairman of the board of trustees of the school. Contemporary in design for its era, the building was designed with French provincial antecedents. It accommodates 117 girls and a house director. The 3.5-story brick structure with a basement also housed the campus beauty shop, two lounges, and a recreation room. (Courtesy of Byron N. Puryear.)

The Grill was constructed in 1946 and served at the first student union. It seated 100 persons and was used by students and staff for short-order dining. An outside contractor, with help from trade students, built the Grill. This was the hot spot of the campus because it had soda fountain service. (Courtesy of Library of Congress.)

Three

EDUCATION FOR ALL

In *Hampton and Its Students* by Mary Armstrong and Helen Ludlow, Hampton's Indian program was described as follows:

On April 18, 1878 around midnight, Captain Pratt brought twenty-one Indians who gladly accepted the opportunity to remain east for education when the prison doors were opened, and the elders went home, Captain R. H. Pratt requested admission for certain of them at Hampton Institute, the only school where they could receive training in industry and self help. This landing was without argument almost the precise spot where the school was established that at the end of the sixteenth century, an Indian village called Kecoughtan were, according to early historians, one thousand members of that tribe dwelt in three hundred wigwams.

Under much scrutiny from the Board, however there was nothing in the liberal charter that mentions race or nationality, but its purpose being defined to be "For the instruction of youth in the various common school, academic and collegiate branches, the best method of teaching the same, and the best mode of practical industry in its application to agriculture and the mechanic arts; and for the carrying out of these purposes, the said trustees may establish any departments or schools in the said institution." Armstrong confidently responded to the opposition, "This new Indian work will give fresh life and force to the school." Captain Pratt, in introducing them to the school officers and students assured, "There will be no collision between the races here. The Indians have come to work." It proved as he said, and the experience of the first ten year confirmed their faith in their work. Not all of the Indians, as with the Colored students, had level-headed sense and determined purpose of those mature, well-disciplined and well-guided, it is true. More or less, prejudice of color was shown occasionally, by some from Indian Territory, where Indians have held slaves. The vast preponderance of experience has been of harmony and mutual helpfulness.

In 1912 the Government appropriation of $167 per student was withdrawn. The decline in Indian enrollment began by the start of the first World War; Indians continued to attend the school until 1923.

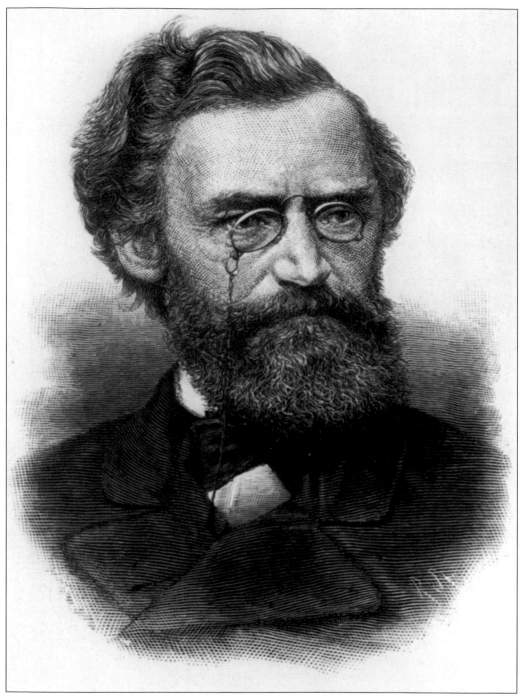

Carl Schurz played a key role in the establishment of education for the Indian students. Appointed secretary of the interior by US president Rutherford B. Hayes, Schurz found the department to be corrupted, which was definitely the case in the Indian Bureau. He reformed his department and the Indian Bureau. He allowed 17 Indians to be brought to Hampton University and watched them partake in the system of industrial education. In 1915, a new academic hall was named in his honor. (Courtesy of Library of Congress.)

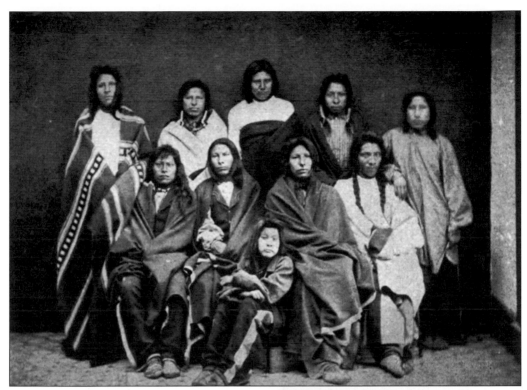

According to *Twenty-two Years' Work of the Hampton Normal and Architecture Institute* regarding the Indians, "When they arrived, they arrived from Fort Marion they were half-naked, crouching forms, with blankets dropping from their gauntness; with savage locks streaming over their eyes, with barbaric ornaments of brass rings in their ears and on their arms; with fierce and sullen faces." (Courtesy of Library of Congress.)

Armstrong entered into an agreement with the US government for the education of the Indians, and funding that was once devoted to fighting the Indians was used for their education in industrial science. The monies were used to clothe, feed, and house the Indians. They were also provided medical care. (Courtesy of HathiTrust.)

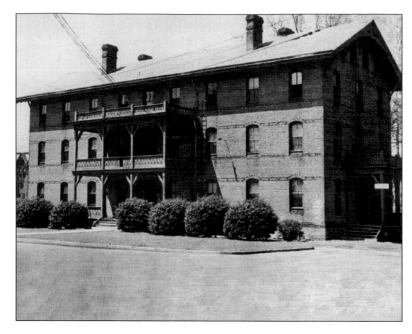

Fulfilling part of the agreement, the Wigwam Building was erected for Indian boys. The building was designed by Charles D. Cake, who had served as foreman on a number of the construction sites on the infant campus. He designed a simple, redbrick structure, 35 by 95 feet and three stories high with a basement. (Courtesy of Byron N. Puryear.)

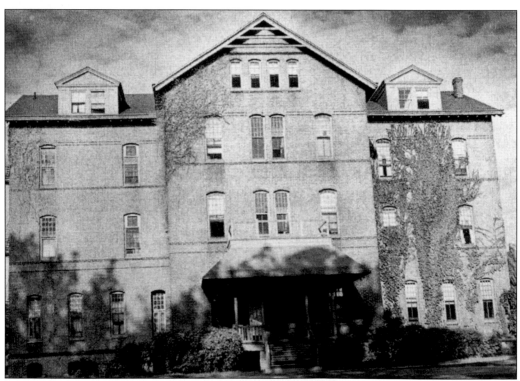

At a cost of $30,500, Winona Lodge was built in 1882 for Indian girls. A four-story brick building was erected in the shape of a Greek cross, with one arm being 100 by 40 feet and the other 84 by 35 feet. It contained rooms for girls and teachers, a laundry room, a hospital, sewing room, study areas, and playrooms. The building was razed to make room for Davidson Hall. (Courtesy of Byron N. Puryear.)

A hospital was erected through donations of King's Chapel of Boston. It was admirably arranged and equipped and has saved the lives of many students. It was considered "bright and airy" and was supplied with reading matter, pictures, and games for patients. In 1886, the school celebrated the opening of the King's Chapel Hospital for Colored Boys and Indians. (Courtesy of HathiTrust.)

The hospital was named for its benefactor, King's Chapel in Boston, Massachusetts. The carpentry department students erected the hospital in the American Cottage style. Though "daintily" furnished, the hospital provided room for 16 male Indian and black patients. Female Indian patients were cared for in the hospital rooms in Winona Lodge. (Courtesy of HathiTrust.)

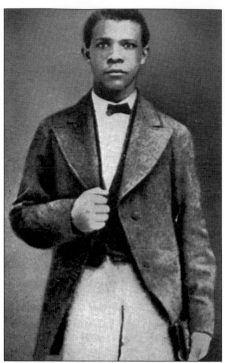

A month after their arrival at school, some Dakota Indians requested to have black roommates to help learn English and American customs faster. Booker T. Washington, assigned by General Armstrong, managed the Indian dormitory. (Courtesy of Library of Congress.)

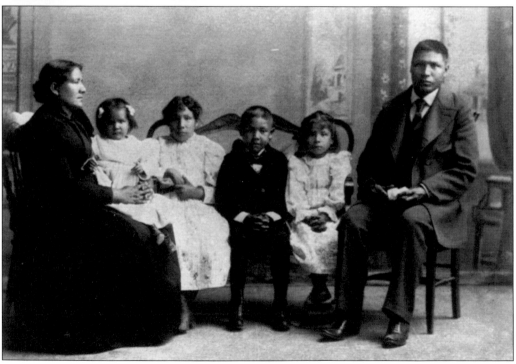

It was not too long before married couples began to arrive on the campus for instruction in housekeeping and domestic life, as well as English and trades. Indian and black students of the trade school constructed six cottages for families. (Courtesy of Library of Congress.)

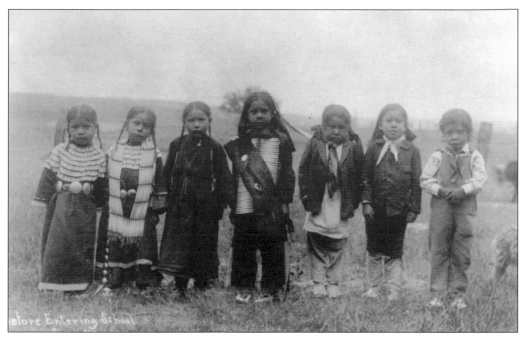

Seven Indian children were born on the campus. When they were old enough, they attended the Whittier School. They were not segregated from the other students; they attended and participated in the same programs and learned manual training. (Courtesy of Library of Congress.)

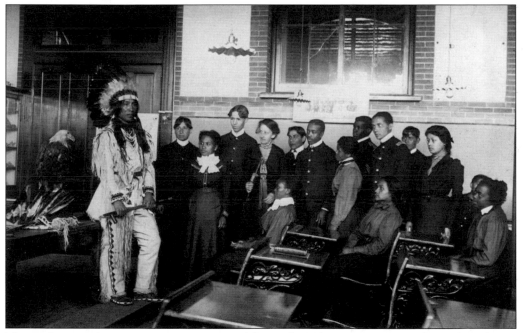

The Indian students were not segregated from the other students except in their living arrangements. Sharing and exchanging customs, Louis Firetail is in his Sioux garb giving a presentation on Indian life in an American history class. The two races were able to attend classes, worship, and dine together. (Courtesy of Library of Congress.)

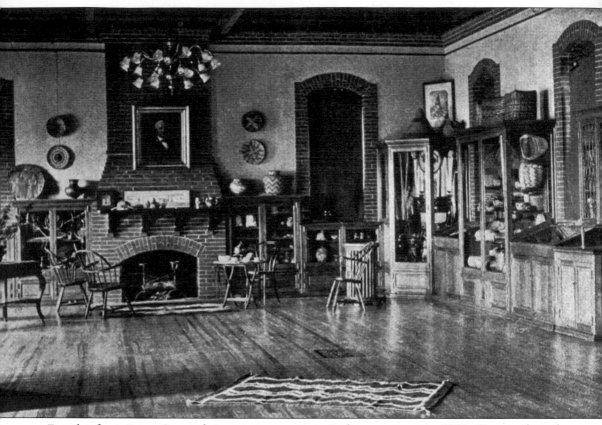

For the first time, General Armstrong went to Indian country in 1881. He purchased several buckskin suits, which were not easily made or duplicated at the time. A school museum curator also made trips to Indian country, which resulted in a wide-ranging collection. In 1905, the Blake Indian Museum, located in old library rooms and named in memory of former instructor Whitney Blake, housed the collection. Displays in the museum showed the belongings of the Sioux people, the Algonkins, and Southwestern tribes, as well as a collection of baskets. Beadwork, pipes, weapons, games, Mound Builder relics, ceremonial exhibits, and articles from Alaska were also found at the museum. Later, Col. E.B. Townsend, C. Briggs, and Joshua Davis made donations to the Blake Indian Museum. Since the museum's creation, the school has constantly added to its collection. (Courtesy of Library of Congress.)

The Indian Orchestra was made up of 10 members. There were three violins, two trumpets, a clarinet, trombone, snare drum, bass drum, and a cello. The students played for visiting donors. Members of the Indian Orchestra were also members of the Cadet Band that performed for parades and other school events. (Courtesy of Library of Congress.)

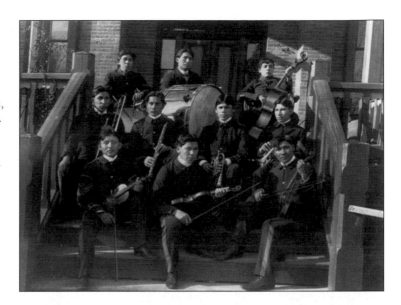

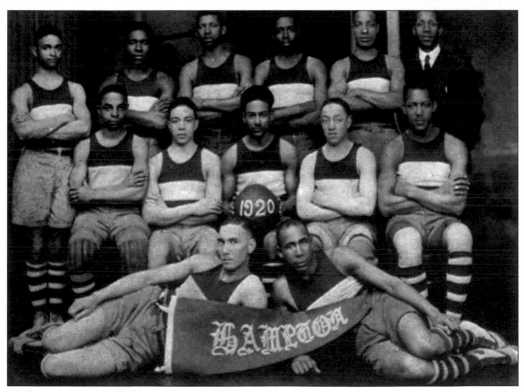

In the interest of all the students, efforts were made to develop organic power, muscular development, and skill. Students were able to participate in basketball, rowing, football, and tennis. Pictured on the third row, far right is Charles Williams; he played a large role in shaping the athletics program at Hampton. A gymnasium was name in his honor. (Courtesy of HathiTrust.)

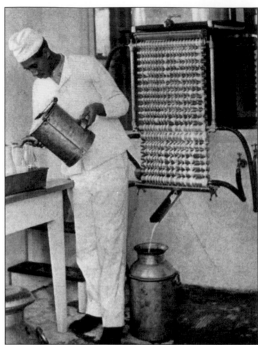

Students participated in manual training, and wages were paid for their work. Male students could enroll in the normal school, trade school, or agricultural science; female students could enroll in the normal school or domestic science school. (Courtesy of HathiTrust.)

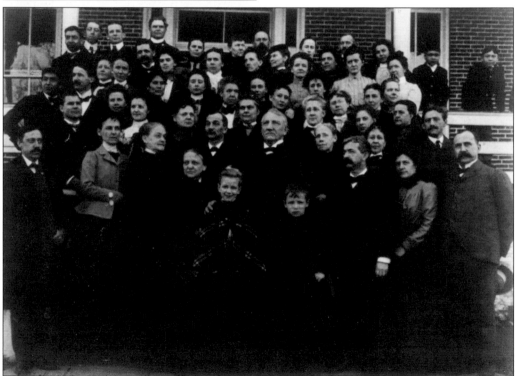

In 1882, the first three Indians graduated from Hampton University. So confident was Carl Schurz of Hampton's schooling for Indians, he brought more Indians to campus and authorized Captain Pratt to establish the Carlisle School for Indians upon the same plan. Colonel Pratt is pictured in the center. (Courtesy of Library of Congress.)

Four

ACADEMICS

In *Education for Life* by Gen. Samuel Chapman Armstrong, Hampton's manual training program was described as follows:

> Many experimentalists who had failed in their endeavors approached Armstrong with their experiences. Armstrong listened attentively to all successes and failures. He then "took careful account of the experience of various experimentalist," regarding the manual training. We believe that whenever a "manual-labor system" is attempted, it should be carefully adjusted to the demands of scientific and practical education."
>
> Armstrong felt that the primary object of manual labor in both departments should be educational; that is, that the work should be first of all done with a view to perfect the student in the best processes, and to make him scientifically and practically a first-class agriculturist and mechanic.
>
> What made this essential was that all schools that were destined to be permanently successful must be founded upon the fact that aid given to them by individuals is not to assist ten, twenty, or fifty young people to support themselves, but to enable hundreds of them to obtain a thorough, practical, and scientific education, in order to develop the industrial resources of the nation.
>
> Evidently such an education must be in the outset expensive, for no harvest can be reaped without liberal sowing of seed; and while institutions which are self-supporting are good, the schools which give the best ultimate results and tell most favorably upon the national life, are those which, while managed with the utmost thrift and economy, have for their primary object education rather than production."

This theory became known as the "Hampton System". "This system, as it stands, is remarkable; because, while it was drawn largely from different sources in our own and other countries, its application to a people scarcely emerged from slavery made requisite certain peculiarities which are particularly worthy of notice as being a direct result of an unparalleled social revolution."

The course was planned for four years; three and one-half years were devoted to academic studies including sufficient industrial work so that the student will have some skill in their trade or science. One-half of their last senior year was spent in either teaching or practical training on the farm or in their trade.

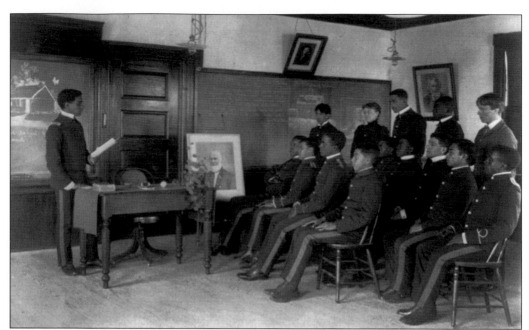

Students were taught English to help with clearness, correctness, and facility of oral and written speech. Instructors believed that correct speaking and correct writing were matters of habit. By encouraging students to practice, teachers succeeded in teaching them English. (Courtesy of Library of Congress.)

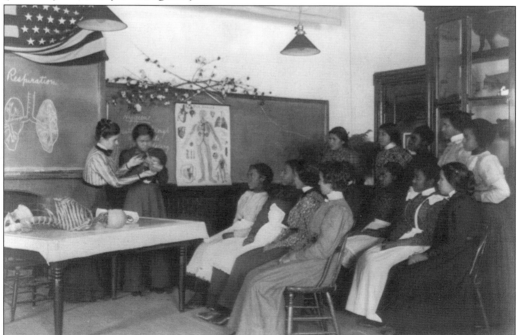

Elementary science was given during the first year. The sole purpose of this course is to acquaint pupils with the more common physical and chemical phenomena in order that they may better understand the nature of these processes in the kitchen, field, and human body. (Courtesy of Library of Congress.)

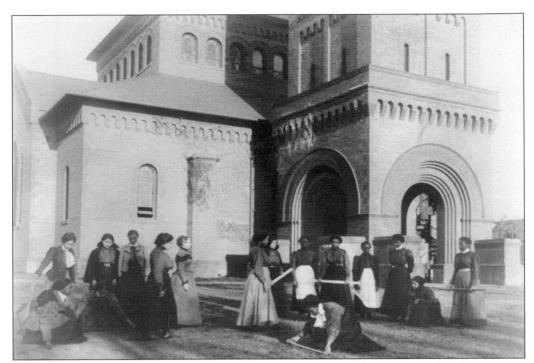

General mathematics was offered in the first year in place of the usual algebra. The overall purpose was to expose the students to a broader field of quantitative thinking and to introduce them to portions of algebra, geometry, and trigonometry. Focus was placed on making mathematics a study of realities, instead of abstractions, and practical use. (Courtesy of Library of Congress.)

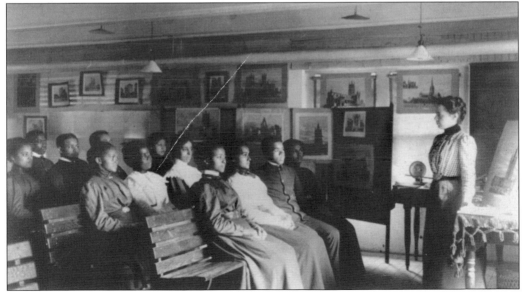

Armstrong approved a curriculum that included general history and ancient history, and an emphasis was placed on great events of Western Europe in the medieval and modern periods. The Christian church and its influence upon the social and political life in Western Europe were also studied each year. (Courtesy of Library of Congress.)

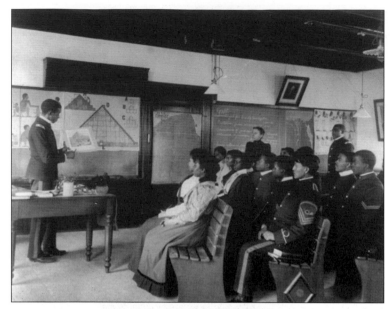

Geography was studied with special attention to physiography, climate, and distribution of people. This was followed by detailed studies of Africa, Asia, Italy, France, Russia, Germany, and Great Britain. Emphasis was laid upon the products and resources, manufactures, commerce, and trade centers of the United States. (Courtesy of Library of Congress.)

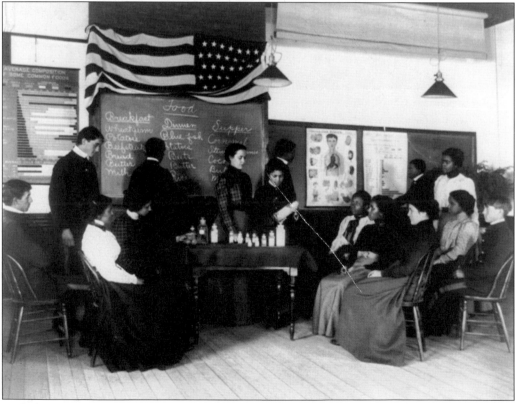

Students took a course in physiology and hygiene during their junior year. The practical course was centered on matters of personal and community hygiene. Physiology emphasized such topics as exercise; ventilation; tuberculosis; contagious diseases; water supply for barn, house, town, and city; patent medicines; and emergencies. (Courtesy of Library of Congress.)

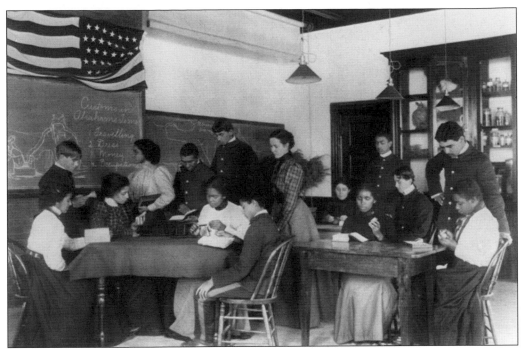

A course on the Bible was offered. It started with a study of the Old Testament and the Hebrew people. This included political enlargement, social growth, and religious development into the breadth, unity, and lofty thing of monotheism. Observe the two white students in the class. According to Cora Mae Reid, children of white faculty members attended Winona and those who graduated and did not go away to school attended Hampton University. (Courtesy of Library of Congress.)

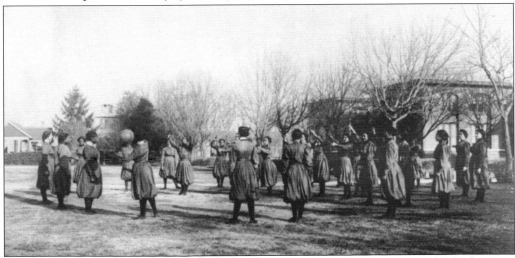

Physical training for girls was based on Swedish or Ling's system of gymnastics, and the gymnasium was equipped with Swedish apparatus. Gymnastic drills included floor work, exercises with apparatus, and gymnastic games. The floor work embraced all the fundamental positions of body, bending, twisting, jumping, running, marching, and so on. Girls were required to set aside two afternoons a week for indoor and outdoor recreation. (Courtesy of Library of Congress.)

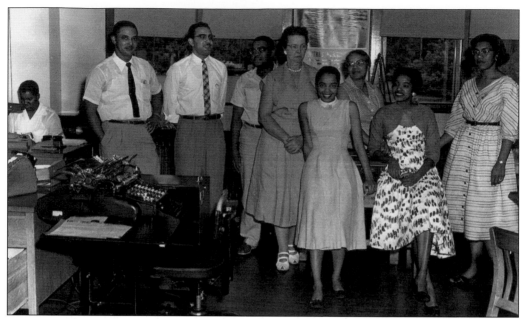

Seniors took courses in the practical study of business matters and methods. Students were allowed to work in campus offices; they were required to maintain hygiene and appropriate dress and character. Pictured are, from left to right, Ralph Burke, Lucius Wyatt, Gus Palmer, Eugene Johnson, Lucy Todd, Charlotte Pearson, Leanna J. White, Althea Jones Scott, and an unidentified student worker. (Courtesy of Library of Congress.)

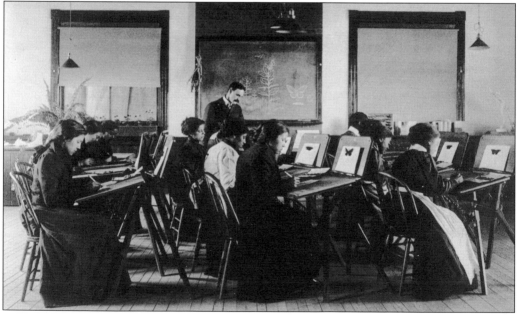

Art instruction was given in two categories, color harmony and pleasing proportion. Pictorial, decorative, and historic art were studied only to develop creative power and good taste. A short course was included during the senior middle year to prepare students for teaching at the Whittier School, and special courses were given to the boys in the trade school. (Courtesy of Library of Congress.)

Five

NORMAL SCHOOL

In *Hampton Normal and Agricultural Institute: Its Evolution and Contribution to Education as a Federal Land-Grant College*, author W.C. John describes the early beginnings of the normal school as follows:

In 1876 Mrs. Walton was one of the first pioneer teachers in the institute work of the Normal School. In 1877 Professor James Johonnot, of Ithaca, New York, conducted an institute for the teachers. In 1876 Professor Allen, of Pennsylvania, held an institute for the benefit of the graduating class and postgraduates who were able to attend. Three lectures were daily delivered, and an examination was held on June 14th at the close of the institute. This was the first technical training in the art of teaching provided by the School. In 1878, Colonel Parker, of Quincy, Massachusetts, conducted the summer institute for the teachers. Miss Bullard, a former pupil of his, conducted the Butler school through that year, making it a school of observation for the seniors. After four years the board found that the Quincy method provided valuable training to the normal school under a skilled teacher and made the Butler School a school for practice teaching.

All Normal School students were required to spend a half-year working under actual public school conditions. By 1921, a trained nurse was provided on Thursday and Friday of each week to the needs of the children who required her services and to the home. The girls of the highest class on the Whittier School received valuable instruction in the care of the sick. Students who wished to participate in settlement work, received the last two month of their training at the Virginia Industrial School for Colored Girls, at Peak, Virginia. This institution was under the direction of Mrs. Janie Porter Barrett, a graduate of Hampton Institute.

By organizing both Butler and Whittier Schools in this manner, [Hampton] Normal School students were given the opportunity to see how a large school is managed in detail with regard to attendance, tardiness, signals, marching, dismissal, morning exercises, etc.: also how a school hot lunch can be prepared and served.

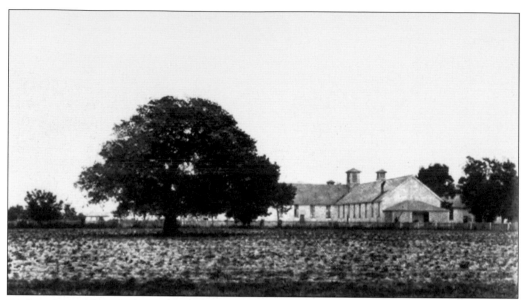

With government funds in 1863, Gen. Benjamin F. Butler, chief commander at Fort Monroe, erected a large wooden building, known as Butler School. The school was constructed for freedmen. (Courtesy of HathiTrust.)

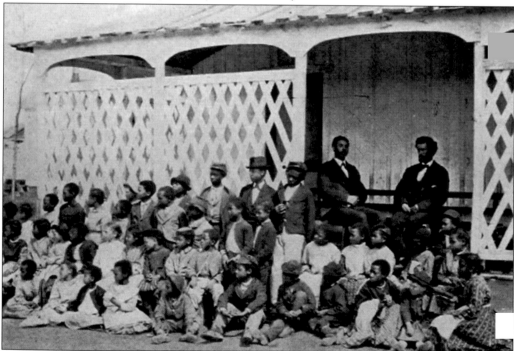

Attendance at the school grew to more than 1,200 pupils. Rev. Charles A. Raymond, who was also the chaplain of Fort Monroe, conducted the Butler School upon the Lancastrian plan. Described as learning by teaching, the Lancastrian plan encouraged students to create the lesson plans for other students. Overcrowding at Butler School was relieved once a school at Slabtown and the Lincoln School were constructed in 1866. (Courtesy of HathiTrust.)

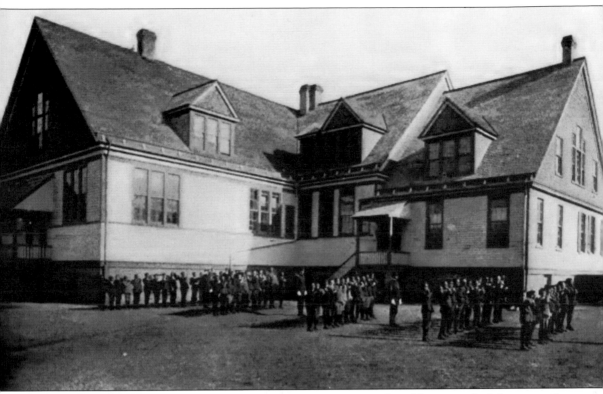

In 1870, when the American Missionary Association surrendered its control of the manual school, the Butler School teachers began taking other assignments. To help supplement the remaining teachers at Butler School, Hampton Normal School trustees voted to give Elizabeth City County the use of a building for a free black school but reserved the right to nominate teachers, resulting in a practice school for Hampton students. This became the first charter school in Virginia for black citizens. The school evolved into a miniature manual training school for "Butler-mites." (Courtesy of HathiTrust.)

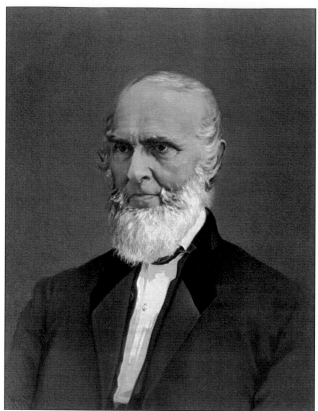

After Hampton became involved with Butler School, Armstrong received a donation from Mr. and Mrs. McWilliams of Brooklyn with the stipulation that the money was to be used for the design and construction of a new primary school building, which was to replace the old Butler School. The new school was dedicated and opened on Wednesday, November 23, 1887; it was a plain but large wooden building, with many modern conveniences of its time, like a kitchen, sewing room, janitor's room, and technical carpenter's shop. It would be natural to name the school after its benefactor; however, the family refused. General Armstrong and the family agreed that the school should be named for John G. Whittier, pictured at left, who had a long relationship of gratitude and affection with the school. (Courtesy of HathiTrust.)

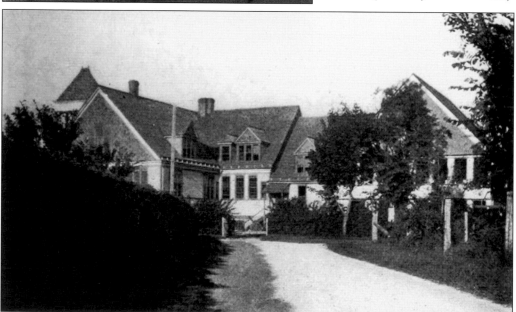

On Saturday, March 1, 1890, the Whittier School was destroyed in a fire, and soon after, Armstrong went out on the hunt for donors for its rebuilding. On Monday, November 24, 1890, the school reopened in a new building that was very similar to the school that was ruined in the fire. (Courtesy of HathiTrust.)

Later, Emily Huntington of New York donated money to the school to be used for cooking classes; Huntington was responsible for supplying the utensils, furniture, and salaries of the teachers needed for these classes. (Courtesy of HathiTrust.)

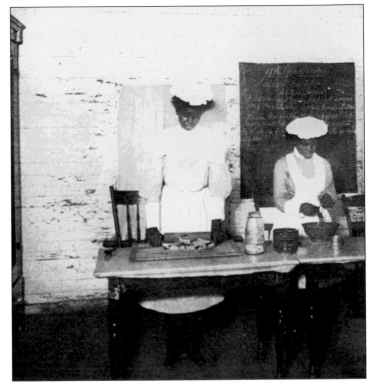

As described in the *Southern Workman*, the Whittier School day began with "a cheerful 'Good Morning,' from the principal and a hymn by the school . . . [and] the Pledge of Allegiance." Note the Emancipation Oak in the background. (Courtesy of Library of Congress.)

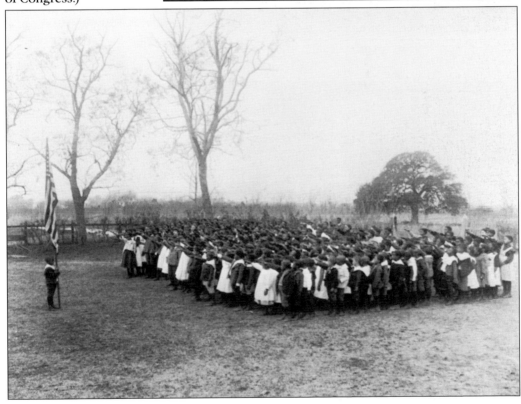

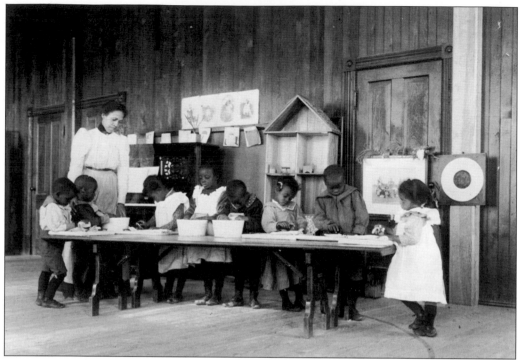

After the Pledge of Allegiance, the children were instructed to wash small clothing items, such as handkerchiefs, dust rags, napkins, and baby clothes, using their washtubs and hot water and soap. After hand washing the items, the young students then boiled, rinsed, and soaked the clothing in bluing water. Lastly, the kids placed everything out on the line to dry. (Courtesy of HathiTrust.)

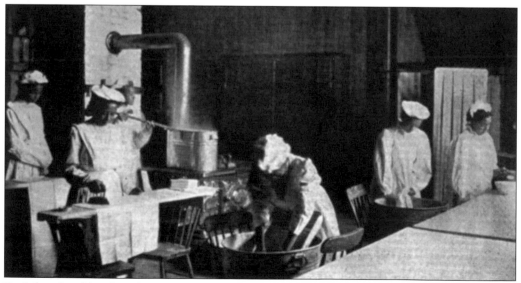

Each week, older female students, as part of their curriculum, did the school's laundry, which included aprons, tablecloths, and napkins. Ironing was also part of the course load. (Courtesy of HathiTrust.)

Each student teacher was put in charge of a group of children and was held responsible for the teaching and control of the room. Students received the same manual training curriculum as the upper school students but on a primary level. (Courtesy of HathiTrust.)

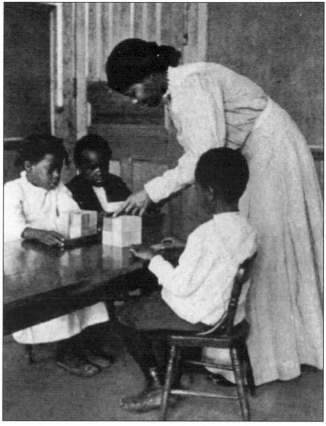

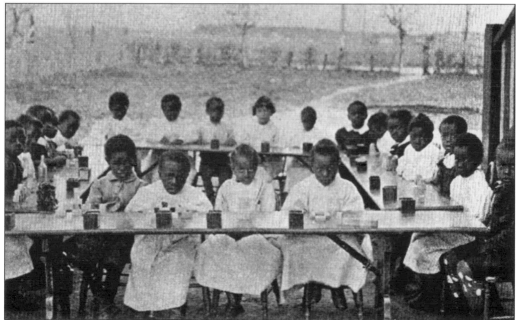

At lunch, students set the tables, and the home economics class prepared the food. Everyone got a hot lunch. (Courtesy of HathiTrust.)

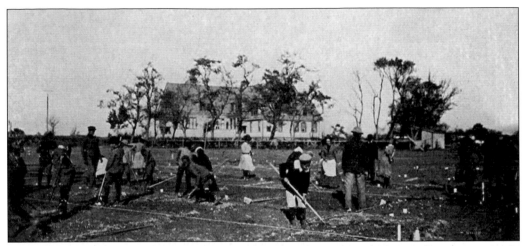

Students were given garden plots to work and were supervised by Professor Goodrich. Goodrich was in the agriculture science program, and his specialty was soil chemistry. Over 200 gardens were maintained by the agricultural students at the Whittier School. (Courtesy of HathiTrust.)

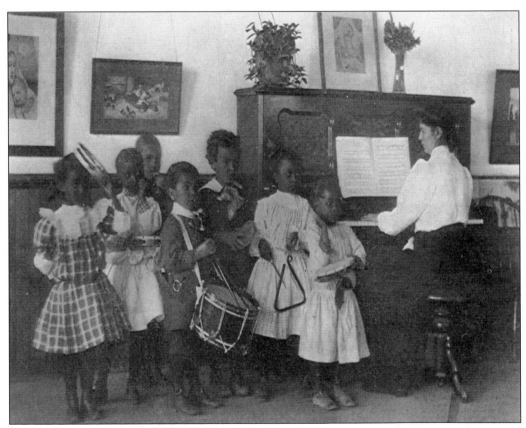

Music class instruction was provided by student teachers from the Hampton Normal School. Whittier School children learned to play drums, tambourines, triangles, bells, and fifes. (Courtesy of HathiTrust.)

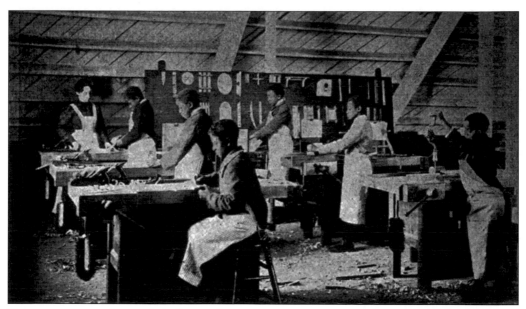

For carpentry students, their first assignment was to construct a box with a lid and hinges. Small boxes had brass hinges, and larger boxes had leather hinges. Students were allowed to keep what they created in class. (Courtesy of HathiTrust.)

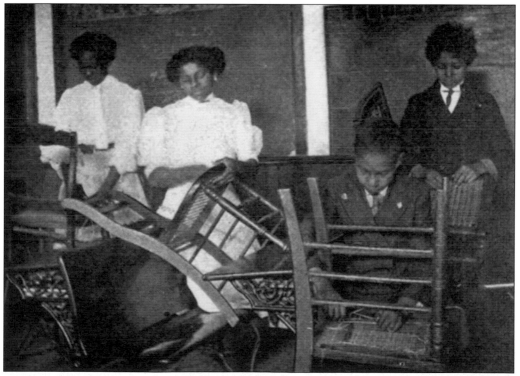

Older students learned chair caning. They also learned how to weave splint, husk, and raffia seats, chair cushions, and mattresses. In order to make mattresses, students used hair, moss, or husk with cotton top; students made doll-sized mattresses. (Courtesy of HathiTrust.)

Winona School was for the children of white workers and was opened September 1920. It enrolled 23 pupils at its start. Dorah M. Herrington was the lead teacher. According to the 1922 Treasurer's Report, white students who were enrolled in the normal school program were paid student teachers. In 1922, Emma R. Flannigan of New York joined the staff. Later, the school was moved to a small wooden building behind James Hall. (Courtesy of Library of Congress.)

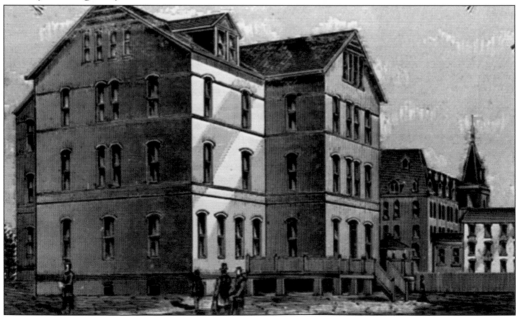

The classes were held in the large Winona Hall, hence the name Winona School. The large hall served many purposes. It was equipped with a small blackboard, one long bench, table and chairs, and, best of all, lots of floor space. (Courtesy of HathiTrust.)

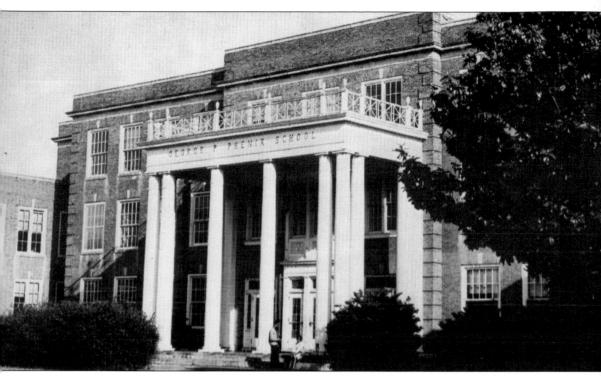

George P. Phenix School was constructed in 1931 by the Harwood Construction Company of Newport News, Virginia, to replace the Whittier School. The cost of the construction was $324,126; the general education board gave a gift of $150,000 with supplemental funds appropriated from unrestricted donations. The Southern Colonial–style building housed 25 classrooms, an auditorium, library, gymnasium on the second floor, a cafeteria on the third floor, and offices for the administrative personnel. At its opening, Hampton operated a private elementary and secondary school in the building. In 1934, it was leased to the City of Hampton for the next 28 years. It provided the only senior high school available to African American students. The elementary program continued at the school during this time, and Hampton students used it to practice teaching. The building was returned to Hampton in 1962 and later housed an ungraded laboratory school. (Courtesy of Byron Puryear.)

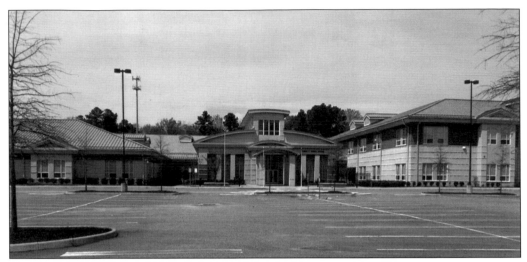

In 2006, Hampton City School Board voted to build a new multigrade school. The design for the school was drawn up by Mosley Architects, a firm based in Richmond, Virginia. Within two years, M.B. Kahn Construction built the school. The school has eight grades, approximately 100 classrooms, two gymnasiums, three science laboratories, and a state-of-the-art fitness room. A committee selected by the school board recommended the school be named Phenix, after the original school. (Author's collection.)

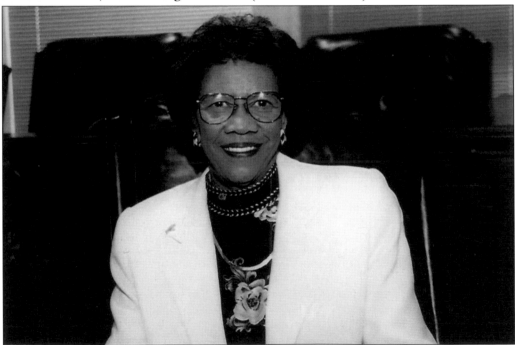

Dr. Mary T. Christian was the youngest employee in the laundry at Hampton when she was recommended to William Mason Cooper, head of the summer school, for a job as typist. She was encouraged to become a teacher; eventually, she was hired as a professor and, later, served as the dean of the School of Education. She was first African American female from Hampton to serve as a delegate in the Virginia General Assembly. (Courtesy of Dr. Mary T. Christian.)

Six

DOMESTIC SCIENCE

In *Hampton Normal and Agricultural Institute: Its Evolution and Contribution to Education as a Federal Land-Grant College*, author W.C. John describes the early beginnings of the domestic science program as follows:

The Domestic Science program dates back to the very beginning of the school. From the first days the young women received training in household duties. Under the careful and able supervision of a conscientious teacher, who realized the lack of training in the fundamentals of decent living that had existed among the freed slaves in the past, the girls were trained in the furnishing and care of their rooms, in their personal habits, in their choice of dress and in its care, and in the performance of all the duties involved in the maintenance of the home. In the industrial rooms or women's labor department, which opened in 1868 and continued through several years, they were offered the opportunity to earn money to defray their expenses while at school. The workrooms of all kinds were as pleasant as any in the institution; the dignity of labor was thus recognized; it was not and could not be regarded as in the least degrading to or unworthy of those who were in the course of study. In 1898, certificates were offered for Domestic Science.

The girls were neither exploited in the interests of the institution nor was her training narrowly restricted to preparation for a trade of for service. Her academic work was enriched by a background of experience that was seldom available to a student while in school. The well-rounded cycle of duties required for the girls and the cooperative spirit in which they must be performed help to prepare them for their future duties in home and/or community.

The dormitories, dining rooms, laundry and sewing rooms have been treated as rich laboratories from which lesson of helpfulness have constantly been drawn. Young women of the middle and senior class were instructed in the art of bread making and of plain cooking, and all the girls do housework, washing, and ironing throughout the course.

Home-demonstration agents and Jeanes industrial supervisors must be trained to carry on the community work in the homes and in the rural schools. Hampton has furnished many Jeanes industrial workers and home-economics teachers to the South.

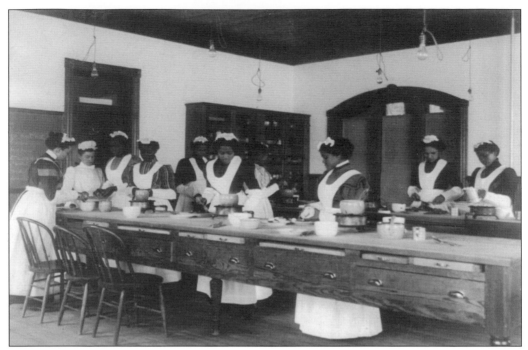

The industrial room for girls was first opened in the barracks by a Ms. Woolsey in December 1868. Here, girls learned to sew and cook. In cooking classes, girls learned about nutrition. (Courtesy of Library of Congress.)

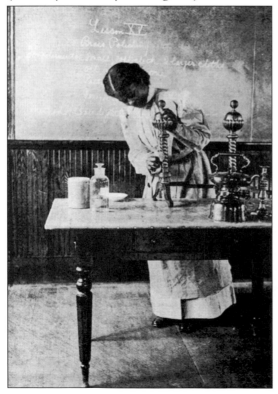

According to *Hampton Normal and Agricultural Institute: Its Evolution and Contribution to Education as a Federal Land-Grant College*, "The practical housekeeping of the institution . . . provided for the girls a large share of their training." The book goes on to say that the housekeeping was "regarded as a necessary corollary to the classroom work." The course consisted of maintaining the dormitories, learning of home sanitation, and preparing and using domestic remedies and disinfectants. (Courtesy of HathiTrust.)

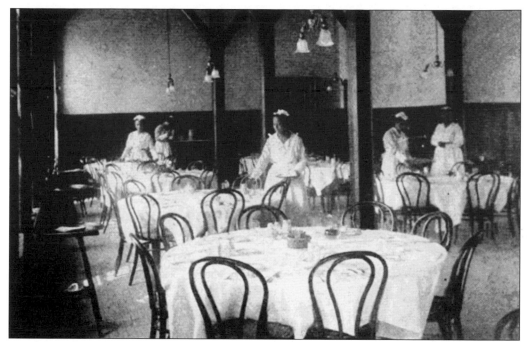

According to *Catalogue of the Hampton Normal & Agricultural Institute, at Hampton, Virginia, for the Academical Year 1910–1914*, the housekeeping course included "waiting in students and teachers dining-rooms; assisting in the teachers kitchen and in the Holly Tree Inn bedrooms, dining-rooms, and kitchen." Here, students learned the timing of service, preparing a side station, and setting a table. They were also taught how to create a menus and basic techniques of table services. (Courtesy of HathiTrust.)

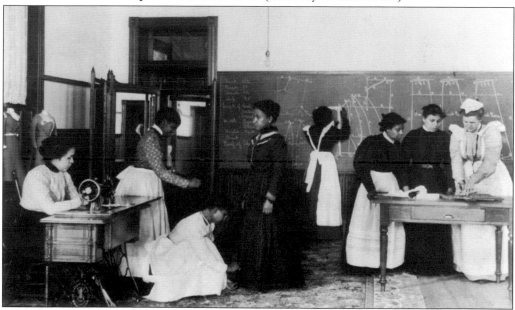

First-year students took sewing. The course included basting, running, backstitching, overcasting, overhanding, hemming, catch stitching, and feather stitching. (Courtesy of Library of Congress.)

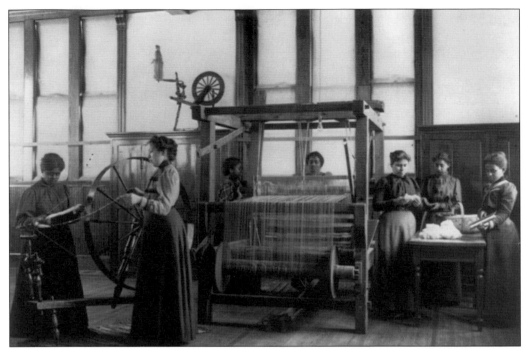

The rug weaving room furnished an interesting and profitable industry for girls. The designs for the woven rugs and the more simple braided rugs were encouraged to exercise their own taste in coloring and designing. (Courtesy of Library of Congress.)

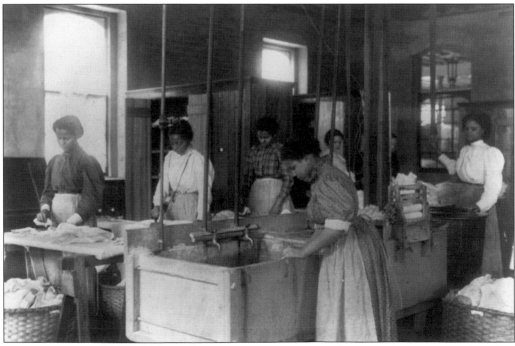

Girls who worked in the laundry received instruction in laundry chemistry so that they understood the principles underlying the best laundry practice. The aim was to make the laundress a thinking and questioning worker. (Courtesy of Library of Congress.)

Seven

AGRICULTURAL SCIENCE

In *Hampton Normal and Agricultural Institute: Its Evolution and Contribution to Education as a Federal Land-Grant College*, W.C. John describes the agricultural science program as follows:

> The first farm operation began in 1868, when General Armstrong and his associates set out to supply the institution's needs for food. The problem of securing a food supply and providing employment for pupils were pressing in the early days as they were in many other industrial or vocational schools. Armstrong established occasional lectures which were designed to give the student an appreciation of the physical and chemical sciences in their relation to farming.
>
> Both the Shellbanks Farm and the Whipple farm were organized into several divisions dairy, creamer, poultry, horse barn, and horticulture. From this re-organization the practical and the scientific; the how and the why; were closely united. A special teacher of agriculture taught the scientific meanings of the daily farm tasks.
>
> Students who were graduating and filling government positions felt the need to further their education. In 1920, the board voted to start a college course in agriculture. Farm experience was required, students had year long farm projects in husbandries, kept accounts that were used in the farm management class; management of animals; participation in opportunities in specialization in an elected branch of animal husbandry; marketing and collecting money; and supervision identifying the difference between good and poor management.
>
> Two sections were offered in the Agricultural course the first section was for young men, the second was for young women who were called upon to teach nature study, or, as homemakers, to manage the family garden. Their course consisted of planting and caring for a garden. This was done on a class basis, but each individual has specially designated responsibilities. There was also a course on ornamental shrubs and flowering plants which were suitable for home and school grounds, as well as instruction in the handling of a home poultry flock. Their class work consisted mainly in the study of the elementary physical and biological problems of soils and of plant growth.

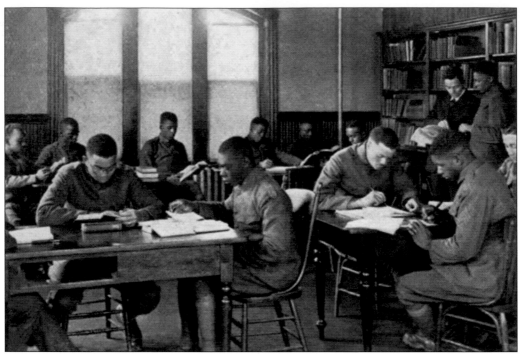

The first satellite library established by the school was the agricultural library. Special time was set aside each day for students to sit and study in the library. The library contained over 300 of the latest books on agriculture, as well as bulletins and magazines. (Courtesy of HathiTrust.)

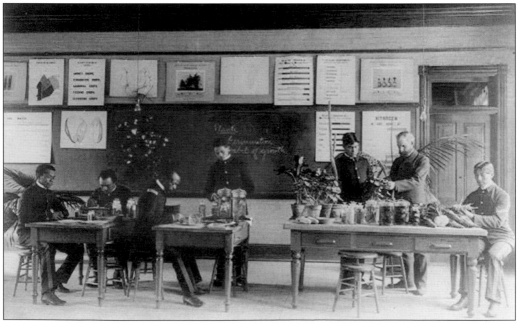

Students learned about the principal parts of plants and about what conditions were necessary for the growth of plants. Students also were taught how to create these perfect growing environments. (Courtesy of Library of Congress.)

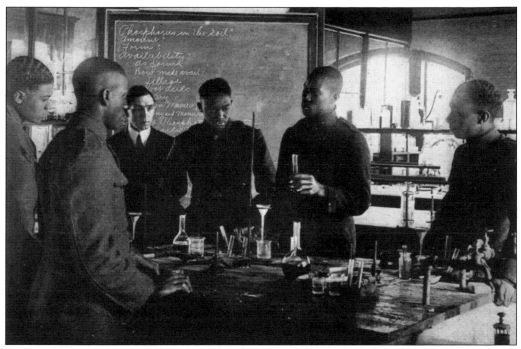

Soil formation was taught to students in their junior and senior middle years. They learned about the ingredients in farm soil, sources of each ingredient, types of soil, some of the rocks from which soils are made, and forces at work making soil. (Courtesy of HathiTrust.)

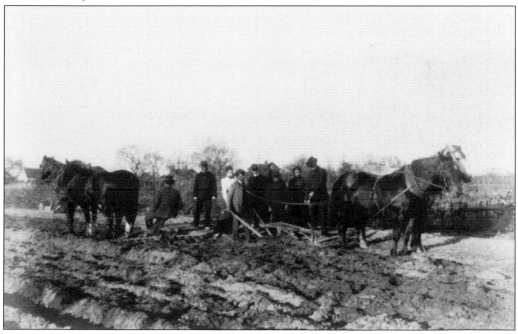

Students were given in-depth instruction in tillage. They learned when to plow and the purpose of plowing. In addition to plowing, students learned the importance of soil texture and forms of water in soil. (Courtesy of Library of Congress.)

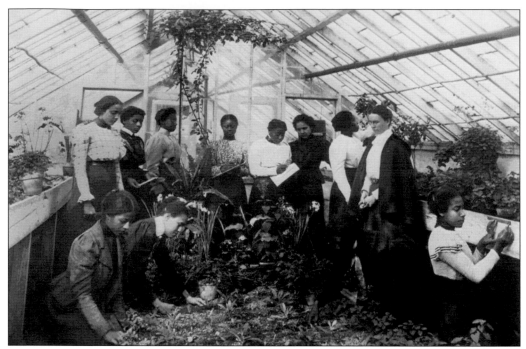

It was important that students understood what was involved in raising, transplanting, and potting small plants and marketing vegetables and fruits. This was done in both the agricultural laboratory and the greenhouses. (Courtesy of HathiTrust.)

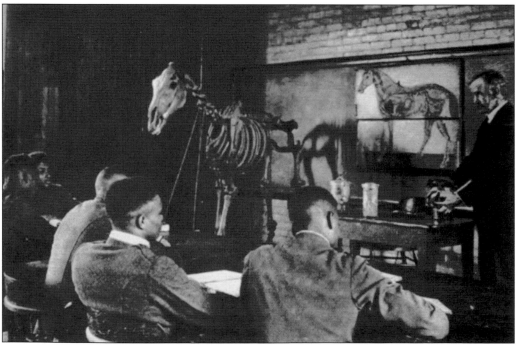

With the help of live models, students learned about the physiology of animals. If the weather was bad, the animal was brought into the classroom. The lesson discussed why certain parts of the animals were superior and others inferior. (Courtesy of HathiTrust.)

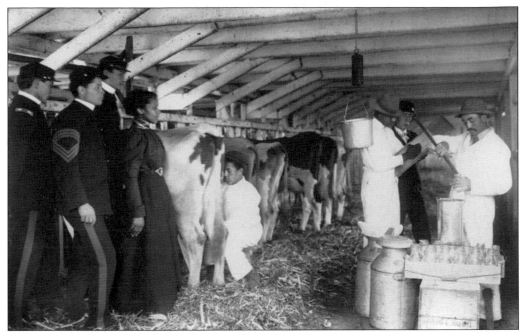

Classes in the dairy involved milking cows and testing the milk; taking care of milk and milking utensils; testing for butter fat; creaming milk by the shallow pan method; ripening and churning cream with the separator; and washing, salting, and marketing butter. (Courtesy of Library of Congress.)

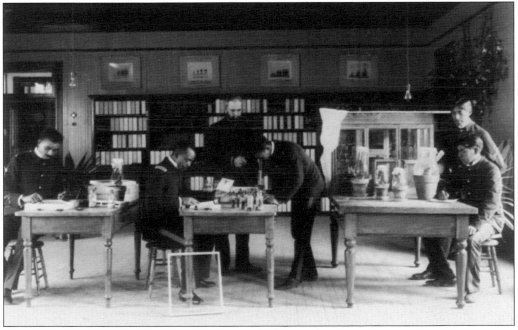

A state-of-the-art laboratory was housed in the Armstrong-Slater Building for the study of entomology. In the lab setting, students learned about some of the common biting and sucking insects, methods by which they may be controlled, and nature's methods in the control of insects. (Courtesy of Library of Congress.)

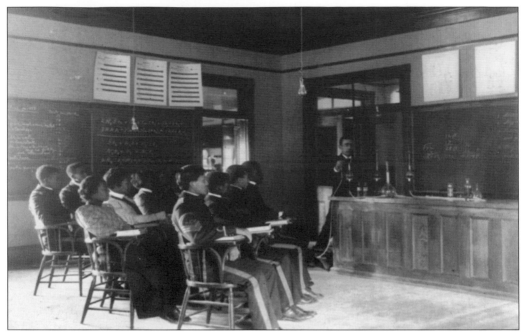

The agricultural chemistry course dealt with problems of chemistry that arise in the daily life of the home and farm. It was expected that students would have at least a year of high school chemistry before entering the agricultural school. (Courtesy of Library of Congress.)

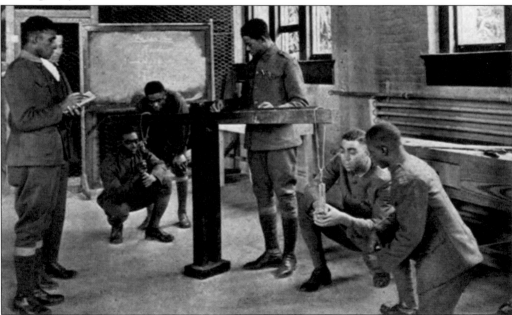

The agricultural physics course was taught as a part of rural engineering. It was studied daily during the fall term, and the class time was split between the recitation room and laboratory. Students studied air and water pressures and the instruments used to record these pressures; students also learned about electricity and heat and their useful applications. (Courtesy of HathiTrust.)

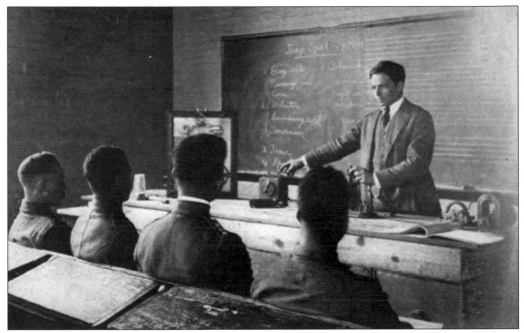

Students taking rural engineering studied the various types of farm machinery, water supply systems, gasoline engine, and tractors. Those who were preparing to be teachers and demonstration agents were required to thoroughly learn about the machines, as they would be giving advice to others in the future. (Courtesy of HathiTrust.)

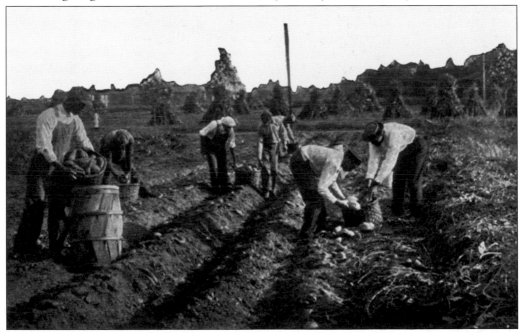

The growing of crops constitutes the majority of work for first-year agricultural students. The course covered the growing of corn, wheat, oats, cotton, legumes, and other Southern crops. Students also learned about plant diseases and insect pests. Here, students are digging for sweet potatoes. (Courtesy of HathiTrust.)

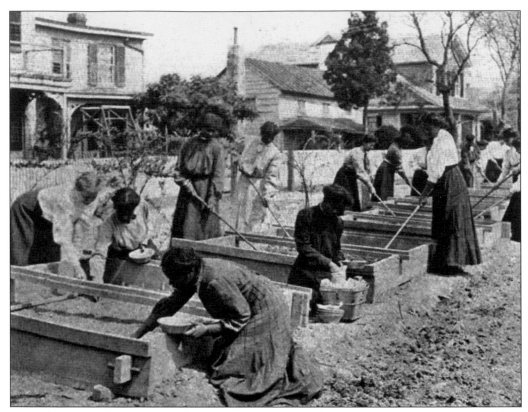

Agriculture was an important subject at Hampton, and the school required each student to learn its elementary principles. The course was nearly the same for both girls and boys. Girls worked in gardens located throughout the campus. They also did experiments that illustrated principles that were applied to the work in the garden. (Courtesy of HathiTrust.)

Annually, students worked and learned about livestock. Students were taught the history and types of beef cattle and were required to rear beef calves and lambs and enter them to be judged in shows. (Courtesy of HathiTrust.)

Eight

TRADE SCHOOL

In the *Annual Catalogue of the Hampton Normal And Agricultural Institute* by Hampton Normal and Agricultural Institute, Hampton's trade school program was described as follows:

The chief purpose of this course was to make men more resourceful in meeting certain emergencies that are constantly arising in the home, on the farm, and in the schoolroom. Students were taught Wood work, harness, repairing, cabinet work, wood turning, mechanical drawing, tinsmithing, tailoring, shoe repairing, blacksmithing, bricklaying and plastering, house and sign painting, upholstering, wheelwrighting, and general repair work.

The Junior year is devoted to elementary wood work, harness repairing, and cabinet work. The wood work is preceded by a short course in mechanical drawing to enable the student to make an intelligent working drawing of the things he will have to construct in wood. Instruction was given in the use and care of wood-working tools, methods of forestry, lumbering, transportation of lumber from the forest to the mill, and its preparation for commercial purposes. Students were instructed on how to solve problems in carpentry and house construction was given to those who intended to take the carpentry course. In the Trade School later, and who show a special aptitude for the work. In the Senior Year the subject that was taken were wood turning, tinsmithing, and mechanical drawing, divided into half-year terms. The student may specialize in a particular branch of manual training with a view to teaching it, or he may practice teaching in the manual training classes at the School, and in the public and evening schools of the neighborhood.

Contract were awarded to the trade-school departments and the student tradesmen solved the difficult problems of house building, including the laying of molded brick on seven-diameter columns, the building of flat arches, and the handling of full-size work. These tradesmen worked as their predecessors had done at an earlier date in building the school's steam laundry, the domestic science and agricultural building, Cleveland Hall, and in converting the old Huntington Industrial Works and Pierces Machine Shop into dormitories for the use of boys. Student tradesmen were paid for their commercial work.

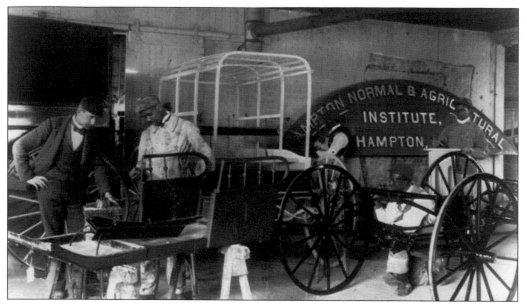

According to the *Annual Catalogue* by Hampton Normal and Agricultural Institute, "[Wheelwrighting] is intended to fit the student to do the building and repairing of automobile bodies, and wagon and cart work that country and city shops are called upon to do. When the course is completed the student is able to build passenger bodies, light and heavy truck bodies, patrols and hearses; carriages, carts, and light and heavy delivery wagons; and also to do general repair work." Today, this type of work is done the body shop class. (Courtesy of Library of Congress.)

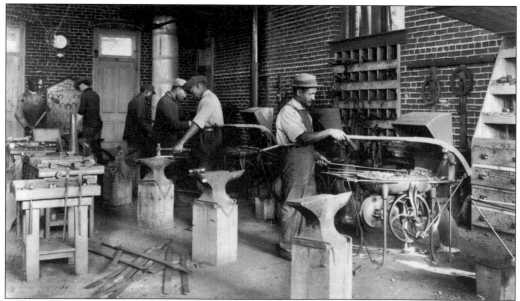

According to the *Annual Catalogue* by Hampton Normal and Agricultural Institute, "[The blacksmithing] department is equipped with all the necessary tools for doing first-class forging, including power-driven trip hammer, punch and shear machine, emery wheel, and blast forges. The student is taught all kinds of general forge work." (Courtesy of Library of Congress.)

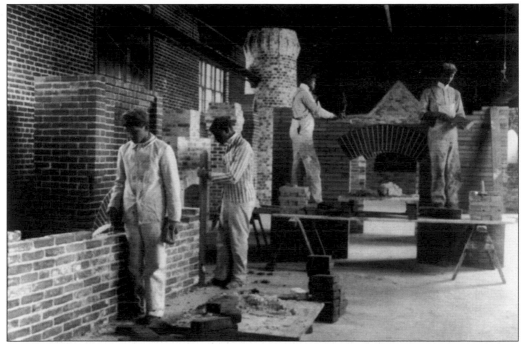

According to the *Annual Catalogue* by Hampton Normal and Agricultural Institute, "The bricklaying course teaches students how to mix mortar, lay bricks to a line, raze a plumb corner, build piers, solid foundations, and walls, and to stake out and square a building. As they advance, students are taught to how to lie out and build different arches, fireplaces, and walls of different bond." (Courtesy of Library of Congress.)

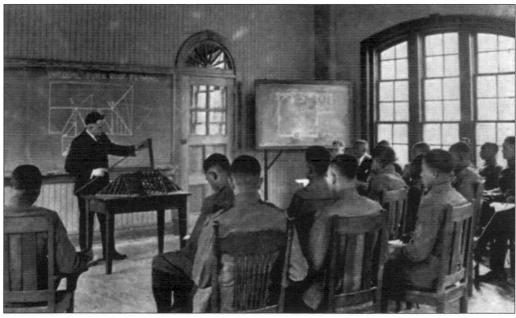

Carpentry students were given a workbench and a complete chest of tools. After students reached a certain level of proficiency, they began practical work. (Courtesy of HathiTrust.)

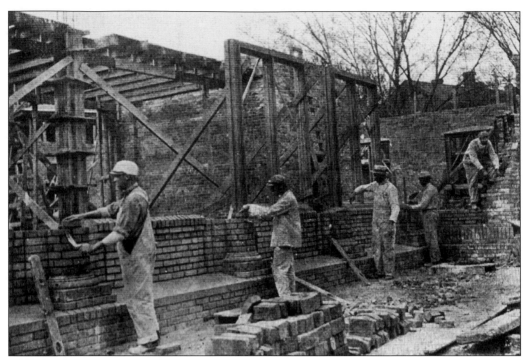

Construction opportunities were provided to students who were interested in either teaching or in constructing buildings or houses. According to *Hampton Normal and Agricultural Institute: Its Evolution and Contribution to Education as a Federal Land-Grant College*, "Student tradesmen construct in the technical shop full-size door and window frames. They learn how to put on the common forms of hardware. In all these operations they work from shop drawings. They learn to use the ordinary woodworking machines and they also learn to manage individual electric motors." (Courtesy of HathiTrust.)

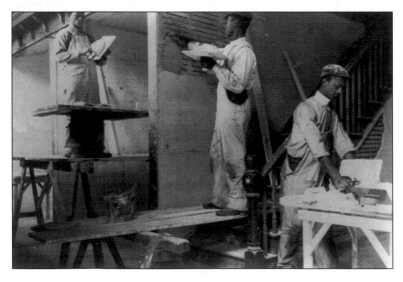

After studying bricklaying, students learned plastering. Both courses were offered in the same shop. After students showed progress in their work and studies, they were then allowed to work on the institute's buildings. (Courtesy of HathiTrust.)

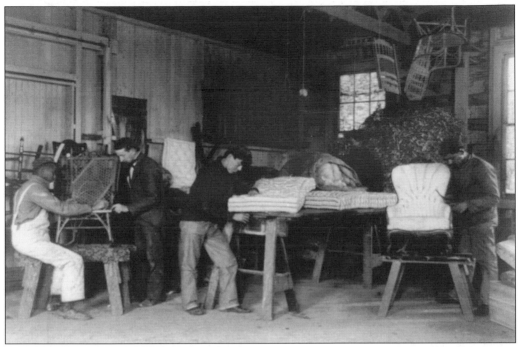

The items made in the upholstery course were used in the cottages and buildings on campus. (Courtesy of Library of Congress.)

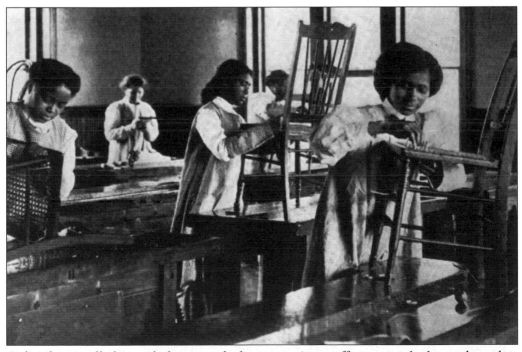

Girls who enrolled in upholstery took the course in an effort to teach the trade and to improve their homes. They were shown how to make boxes, casks, barrels, and other items like cozy seats, footstools, and shoe racks. (Courtesy of HathiTrust.)

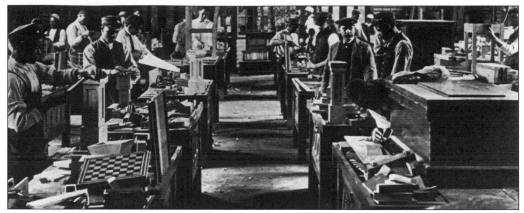

Once they had mastered their tools, cabinetmaking students were allowed to help repair cabinets, desks, bookcases, chairs, and tables on campus. (Courtesy of HathiTrust.)

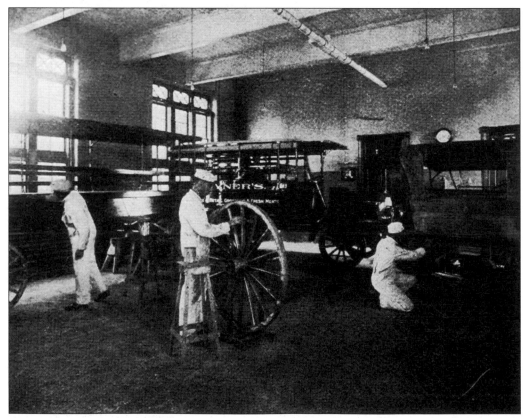

The paint department was located in the Armstrong-Slater Building. According to the *Annual Catalogue* by Hampton Normal and Agricultural Institute, "One side of the room in which painting is taught is partitioned into booths, or small rooms, the walls of which are arranged to represent the inside and outside of houses, and on these, students practice the various parts of their trade. On the walls of the main room is ample space for stenciling and other forms of decoration." (Courtesy of HathiTrust.)

According to the *Annual Catalogue* by Hampton Normal and Agricultural Institute, "The steamfitter's course comprises instruction and practice in all the piping and connections necessary for the heating of buildings, connecting of engines, boilers, and water-supply mains, both wrought and cast iron." These students worked in the black apprenticeship program at the Newport News Shipyard. This program was created by C.P. Huntington before his death. (Courtesy of HathiTrust.)

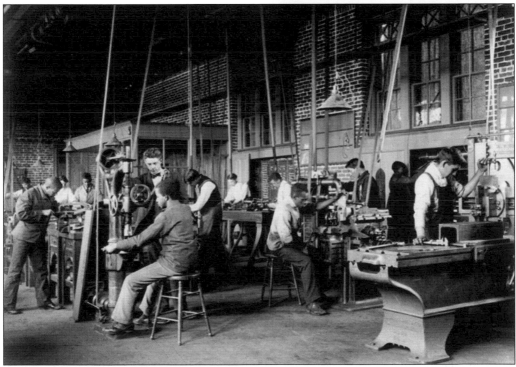

Students in the machine work department learned to make gears, repair gas and steam engines, rebore cylinders, and make new pistons and rings, to name of few of their lessons. (Courtesy of HathiTrust.)

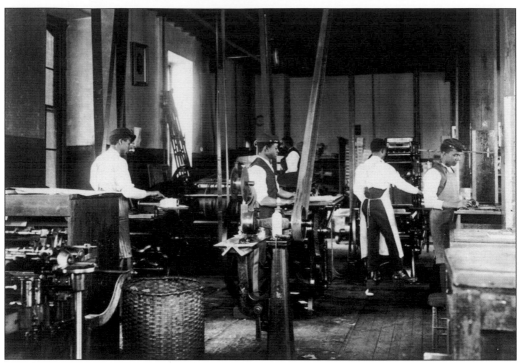

The printing department has been housed in several locations—the Marshall Building, Stone Building, and the library's basement. Its publications and printings have been sent to all parts of the world, in response to requests, catalogs, reports, and literature descriptive of the Hampton School and the type of education for which it stands. It also sent materials for debates and essays on race questions and industrial training. (Courtesy of HathiTrust.)

The *Southern Workman* was an illustrated monthly magazine, established in January 1872 by General Armstrong. He made this journal a vehicle to carry his ideas abroad and enlist the interest of all the people he was able to reach. (Courtesy of HathiTrust.)

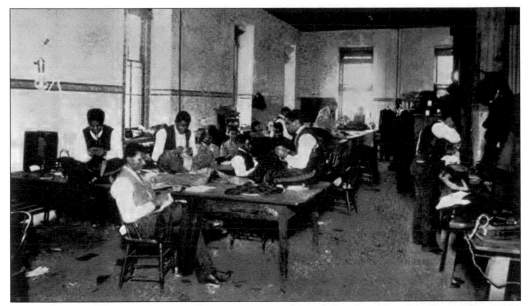

Tailoring students learned to sew by hand and by machine; the course also prepared students to be businesspeople. Many of the items the students made in class could be seen on people around campus and town. (Courtesy of HathiTrust.)

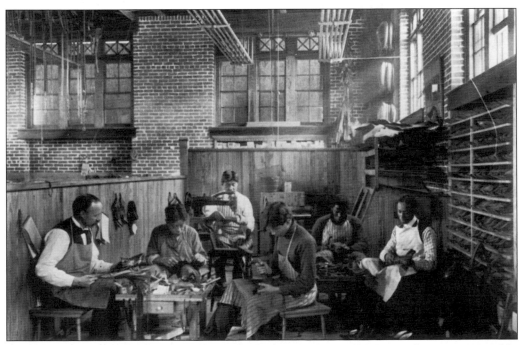

Students were taught to use then modern shoe-repairing machinery and were responsible for taking care of the footwear of over 800 boarding students and some 200 Hampton Institute workers. (Courtesy of HathiTrust.)

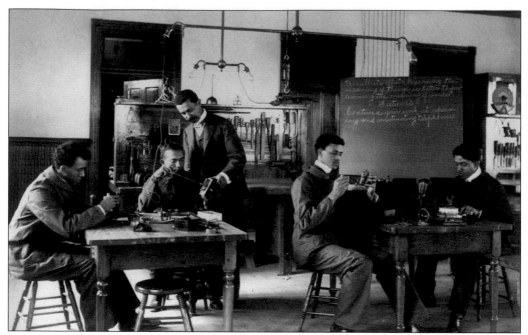

Armstrong believed that the school should be polytechnic, and so the college often accepted a variety of contracts from the government and corporations. The students pictured are taking a course in telephone construction. (Courtesy of HathiTrust.)

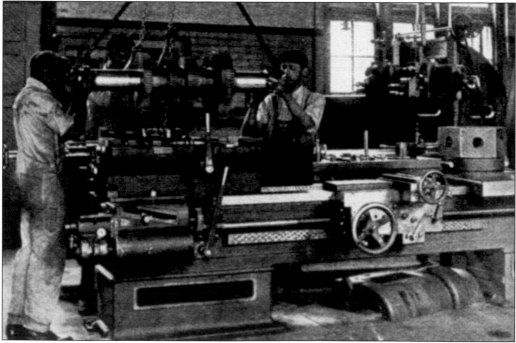

The mechanics course included the study of the laws of physical and mechanical principles; this encompassed the strength of material, weights and measures, transmission of power, magnetism, and electricity. In addition to a general course, emphasis was placed on their chosen trade. (Courtesy of HathiTrust.)

Nine

MILITARY TRAINING AND DIXIE HOSPITAL AND HAMPTON TRAINING SCHOOL FOR NURSES

According to the *Annual Catalogue of the Hampton Normal And Agricultural Institute* by Hampton Normal and Agricultural Institute, at the start of the military training program, under General Armstrong, "All the young men [were] members of the school battalion. With the exception of the Commandant and his assistants, and the instructors in military science, all the officers of the battalion [were] drawn from the student body and [were] promoted from year to year as vacancies occurred." Reported in the *Southern Workman*, the Reserve Officer's Training Corps (ROTC) was authorized by an Act of Congress in 1916 "and flourished . . . until the institution of the Student Army Training Corps was re-established in 1919." The primary object of the ROTC was to provide systematic military training to qualify selected students of such institutions as reserve officers in the military forces of the United States.

The *Southern Workman* reported, "When the work of the Dixie Hospital was begun, it was entirely experimental." The magazine stated that Alice M. Bacon saw the need for hospital work and that her goal was to "[open] the service of trained nurses" in order to "train [the] colored girls as to make them superior to the unskilled nurses who [did] most of the sick-nursing." They solicited help from Northern donors who were more than willing to donate to the hospital and training school. With one patient and two student nurses under the instruction of a resident physician and a trained nurse, Dixie Hospital was opened in June 1891. According to the *Southern Workman*, "Physicians of Hampton and the Soldiers' Home came regularly to lecture to [the] little class of students." The board for the school was able to secure contracts that hired the nurses to help pay for salaries, services, and expenses. Originally, the building was located close to the county road and the Whittier School but was moved to a site not far from the Soldiers' Home gate. The property was leased from the school.

On July 19, 1965, Mildred Smith would file suit against the school for discrimination, challenging the segregated hospital cafeteria. Though there is much speculation over the reasons for the school closing, ultimately the Dixie Hospital and Training School for Nurses charter was reorganized to eliminate the nursing school, and the hospital was moved off the campus to Victoria Boulevard. Later, the institute added nursing to program offerings.

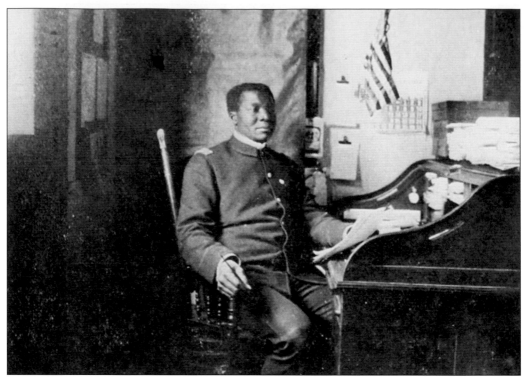

The school carried out the military tactics of West Point. The commandant at Hampton was invited up to West Point, and there, he studied tactics for several months. Robert R. Moton served as the school's commandant at the appointment of General Armstrong. (Courtesy of HathiTrust.)

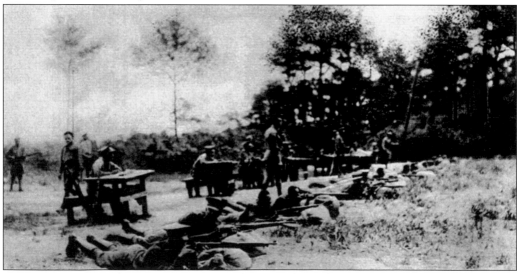

Hampton's black companies were allowed the privileges of Fort Monroe, and officers from the fort drilled the students at either site. Thus, every Hampton male student was a well-trained soldier. Military training taught the boys teamwork. To carry out orders, men had to exercise obedience and self-control, not only of the body, but also of the mind. (Courtesy of Hampton Public Library.)

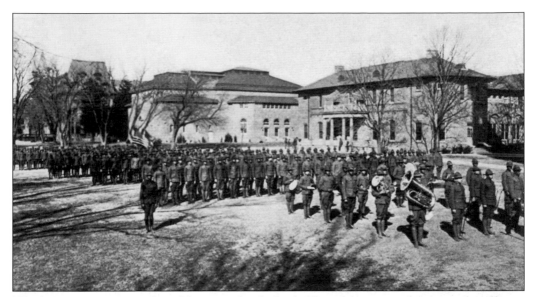

The boys were required to be properly clothed. The cadets served as morale officers and as a student police force. The uniform often saved boys from temptations, and consequently, there were very few cases of immorality. (Courtesy of HathiTrust.)

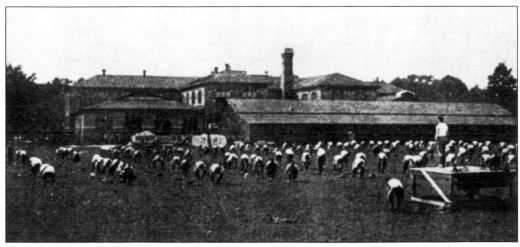

Physical measurements were taken at the beginning and end of the school year, and each student was fitted for a uniform. Cadets were expected to maintain their health and physical condition throughout the year. They participated in workouts and were expected to use the gymnasium in their down time to maintain the strength and weight. (Courtesy of HathiTrust.)

According to the *Annual Catalogue* by Hampton Normal and Agricultural Institute, "The War Department [authorized] the establishment of a unit of the Reserve Officers' Training Corps at Hampton Institute, which [included] all physically qualified men." The books goes on to say, "At least three hours a week [were] required for setting-up exercises, military drill, and instruction in military science." The Charles H. Williams Gymnasium was built to provide cadets with a state-of-the-art facility to work out. (Courtesy of Byron N. Puryear.)

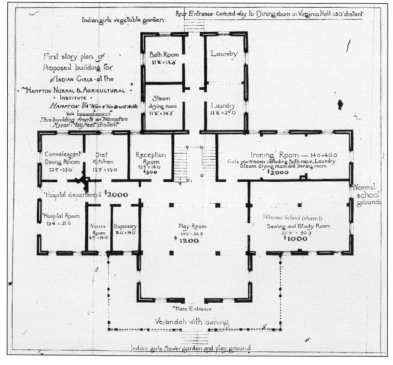

Health care at the school dates back to its beginnings in the barracks. One of the barracks was dedicated as an infirmary for the students. There were three locations on campus where female students worked—Winona, Kings Hospital, and the Abby May House. Alice M. Bacon saw the need for a nursing program that would extend to homes off campus. The Dixie Hospital and Training School for Nurses charter was born. (Courtesy of HathiTrust.)

The land for Dixie Hospital was purchased for the sum of $7,500 for 7.3 acres. Through the combined efforts of Alice M. Bacon and Thomas Tabb, the Virginia General Assembly incorporated the Dixie Hospital and Training School for Nurses on March 4, 1892. Its founding board members were Dr. S.K. Towle, General Armstrong, Thomas Tabb, Jacob Heffelfinger, Dr. J.T. Boutelle, Rev. J.J. Gravatt, P.T. Woodfin, and Alice M. Bacon. The Dixie Hospital on the school grounds, inspired and pushed by Alice M. Bacon, worked to help both whites and blacks. It was at no expense to the school. As a training school for nurses, it was self-supporting by nurses fees; only it buildings and outfit were charity. Today, Dixie Hospital has evolved into Hampton Sentara Careplex Hospital, housing 224 private rooms. It is considered a technologically advanced hospital and stroke center. (Illustration provided by Jonathan Davis.)

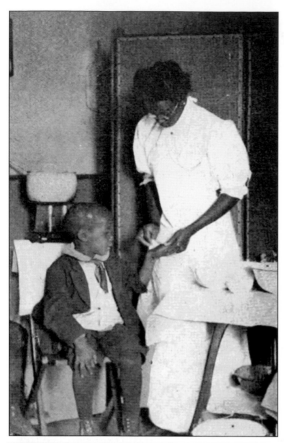

The hospital served those who needed help paying. The district's visiting department provided nurses who made visits to schools and homes; they not only gave bodily relief, but also taught the gospel of cleanliness, proper care, and good cooking. They fulfilled a high and beautiful ministry to the poor, sick, and dying. Nurses were frequently called to the Hygeia Hotel and Fort Monroe to tend to the sick. (Courtesy of HathiTrust.)

Pictured at center, Nana Winbush, RN, BSN, graduating with honors in 2005, participates in the Hampton University School of Nursing Pinning Ceremony. The Hampton University School of Nursing pin is a representation of the middle of the Hampton University seal. The pin symbolizes the transition from student to nurse. Nana Winbush was among the first graduates of the Hampton University School of Nursing's satellite campus in Virginia Beach, which opened in 2003. (Courtesy of Nana Winbush.)

Ten

ATHLETICS, ACTIVITIES, AND GRADUATES IN THE COMMUNITY

Charles H. Williams, a graduate of Hampton Institute, earned his master's degree in physical education from Harvard University during summer school in 1930. Upon his return to Hampton, he worked actively to organize student sports. He established the athletic associations on the campus for both boys and girls. There was a nominal fee of $1.50 per student for both organizations. The Boys' Athletic Association was organized with football, basketball, baseball, tennis, track athletics, and rowing. The Boys' Athletic Association was a member of the Colored Intercollegiate Athletic Association (CIAA).

Charles H. Williams was the leader in the founding of the Colored Intercollegiate Athletic Association, also known as the Negro College Conferences, organized in February 1912. Other founding members include Allen Washington and George Johnson of Lincoln; W.E. Atkins, Charles R. Frazier, and H.P. Hargrave of Shaw; and J.W. Barco and J.W. Pierce of Virginia Union. The first CIAA constitution was published in the Inter-Scholastic Athletic Association handbook of 1913.

The Girls' Athletic Association included basketball, tennis, hockey, and other outdoor games. The director of physical training supervised the association. Match games were arranged between class teams and not various schools like the boys' association. In 1972, Pres. Richard Nixon signed Title IX of the Education Amendment, which stated that educational programs receiving federal monies could not exclude participation on the basis of gender—hence, the birth of women's sports in schools and colleges.

Williams, with help from Bernice M. Smothers, also established the Hampton Institute Creative Dance Group. The group's performances were based on Negro spirituals and the traditional African dances; members were instructed by Williams and Smothers. The troop's first appearance was at Ogden Hall on April 2, 1934. The troop went on to perform in New York City on November 21, 1934. Among its graduates is Vera Embree, a writer, choreographer, director, and producer who went on to become an important force at the University of Michigan's Schools of Education and Music. In 1984, the Michigan Legislature honored her with a resolution that bestowed on her "a unanimous accolade of tribute and praise" and proclaimed her "most deserving of recognition."

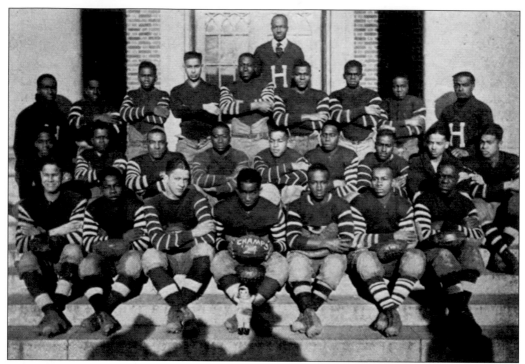

The origins of the Hampton football team began as early as the invention of the game. Early games were played on the lawn in front of Virginia Hall. After the founding of the CIAA, football took on new appeal with the scheduling of other schools to play against. (Courtesy of HathiTrust.)

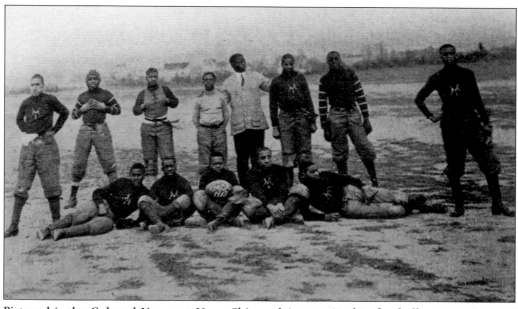

Pictured is the Colored Newport News Shipyard Apprenticeship football team with the Y Athletic teams. The shipyard reserved a 75-by-100-foot athletic space for black industrial workers so that may participate in recreational sports. (Courtesy of HathiTrust.)

In 1973, Dr. Walter Lovett Sr. was appointed head coach of the Hampton team. In 1976, he led the Hampton team to become the only undefeated team in the state of Virginia. Upon being appointed athletic director of Hampton, he initiated youth programs, such as the National Youth Sports Program. It was the first of such in the area that introduced youth to organized sports. (Courtesy of Walter Lovett, Sr.)

Girls' basketball began as early as the boys' team, using a peach basket on a pole. As with the men's team, it developed but only to class teams playing each other and not within the CIAA. After the 1972 amendment from President Nixon, members of the CIAA began raising money to support women's sports. The first championship game took place during the 1974–1975 school year; Hampton won its first Women's CIAA Championship in 1984. (Courtesy of HathiTrust.)

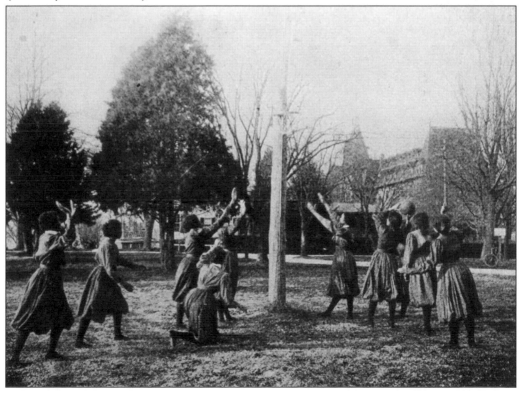

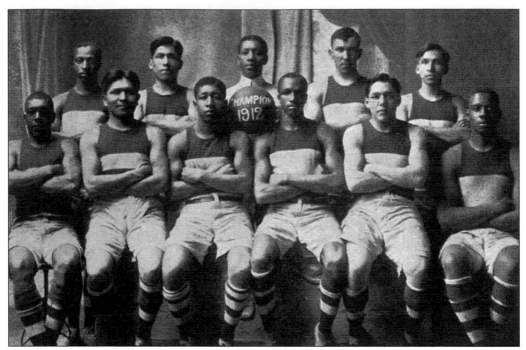

The boys' basketball team dates back to 1910. In late February 1912, in what is considered the first black intercollegiate game ever played, America Howard Institute came to Hampton. Hampton gained an early advantage; the Howardites tried to come back but fell short by three points. Hampton became the champions 19-16. (Courtesy of HathiTrust.)

Prior to the founding of the CIAA, students raced each other or held small games with other schools. Once the CIAA was established, track and field became a formal sport, with the establishment of rules, specific races, and a schedule of meets with other schools. (Courtesy of HathiTrust.)

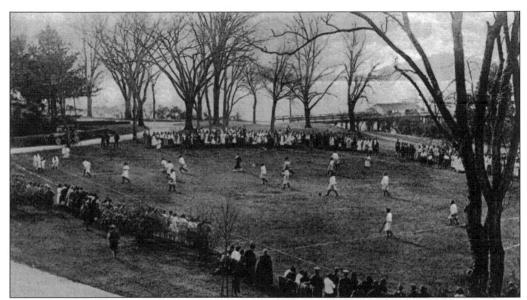

Girls' field hockey was played on the lawn between the shore and Marshall Hall. Coach Lovett, former head director of the athletics department, stated that students played by themselves or within an intramural division. (Courtesy of HathiTrust.)

Many notable sports legends visited the college to speak to the students. Among them was Jackie Robinson, who visited the city to promote the fundraising for a baseball stadium on Pembroke Avenue. Due to Jim Crow laws, he could not stay in an area hotel; he resided in the home of T.F. and Naomi Robinson Johnson at 1 Langston Drive in Hampton. (Courtesy of Naomi Davis Estate.)

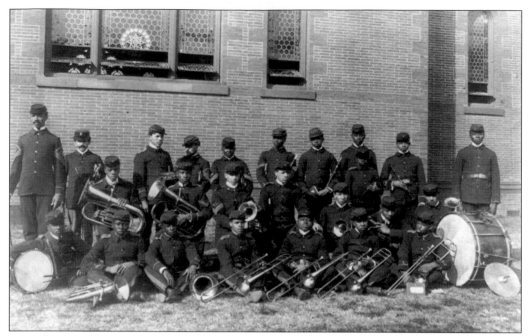

According to Al Davis, Hampton University band director, "The campus Marching Band dates back to 1912"; this date coincides with the founding of the formal football team under CIAA. However, prior to performing at football games, the campus band performed in parades and events on campus under the military science program. Today, there are 10 instrumental sections of the band. (Courtesy of Library of Congress.)

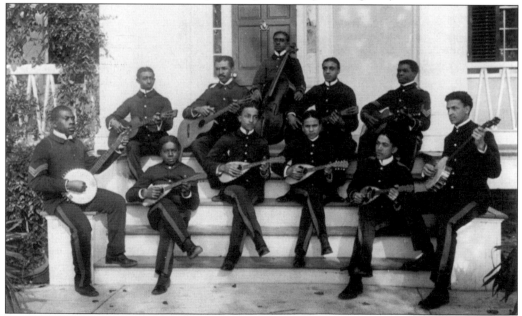

Pictured is the guitar and mandolin band, and contrary to its name, the band was actually made up of a variety of string instruments. Students are shown playing banjos, guitars, mandolins, and the cello. They played for a variety of events and played songs ranging from ragtime to waltzes. (Courtesy of Library of Congress.)

It is believed that Nathaniel Dett created the Hampton boys' and girls' glee club after the war. In 1930, the choir and glee club set sail for a tour of eight European countries—England, Scotland, Wales, France, Germany, Austria, Italy, and Belgium. In each of the cities, they received the highest praise from the press and public. Wilhelmina P. Patterson often accompanied the group. (Courtesy of HathiTrust.)

Considered one of the fathers of black music, Nathaniel Dett came to Hampton Institute in 1913 after having received his bachelor of music degree and studied at Harvard University under Arthur Foote and the American Conservatory at Fontainebleau with Nadia Boulanger. In 1914, he directed the 40-voice choir at Carnegie Hall. He was appointed director of the music department at Hampton in 1926; he was the first African American to hold this position. (Courtesy of Library of Congress.)

FRISSELL MEMORIAL ORGAN PRESENTED BY GEORGE FOSTER PEABODY FROM THE PALMER FUND

Pictured is the Royal Hamptonian, led by "Jap" Curry. This band travelled the United Service Organizations (USO) circuit, playing a variety of music from swing to the waltz. Among the renowned musicians who played with this band were Jap Curry and Pee Wee Moore. Jap Curry is most known as a composer and played his music with is band Jap Curry and the Blazers. Pee Wee Moore has recorded with artists like Dizzy Gillespie. (Courtesy of Clarence "Jap" Curry.)

The Hampton Quartet has been in existence since the founding of the Hampton Singers. The quartet achieved great fame in the General Armstrong era. They sang quaint Negro spirituals in the traditional manner heard in the South. Pictured are, from left to right, (sitting) Jeremiah Thomas and W.E. Creekmur; (standing) John Wainwright and James Bailey. (Courtesy of Byron Puryear.)

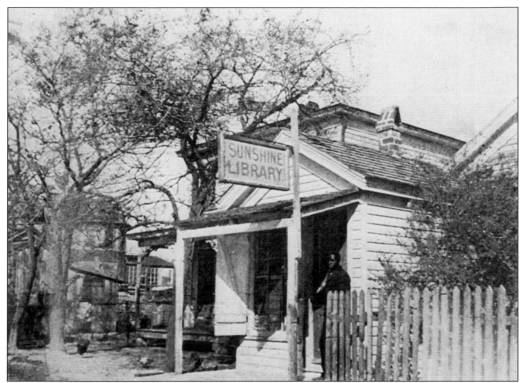

The Sunshine Library was established by Lottie Smith-Davis, class of 1874, in July 1900 in Phoebus, Virginia. The *New York Times* called it the smallest circulating library in the world! The library was seven by nine feet in size. (Courtesy of HathiTrust.)

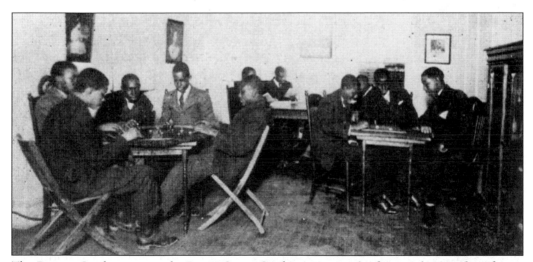

The Barrett Settlement, or the Locus Street Settlement, was the first settlement for African Americans in the United States. It was founded by Athens, Georgia, native Janie Porter Barrett, a graduate of Hampton Institute. Here, youth from the community met to study, play board games, and do other activities. Females from the community participated in domestic science activities, and preschoolers participated in structured play. (Courtesy of HathiTrust.)

Within the community and the campus, there grew a need for the arts and humanities. Rufus Easter, a graduate of Hampton and an instructor, served as an organizing member of the Musical Arts Society at Hampton. He visited New York to bring in a variety of acts to expose the community to the humanities. Ogden Hall was filled with performances by the Chicago Dance Troop, Duke Ellington, Marion Anderson, Aretha Franklin, and many other up-and-coming entertainers. The committee required that all events be integrated seating.

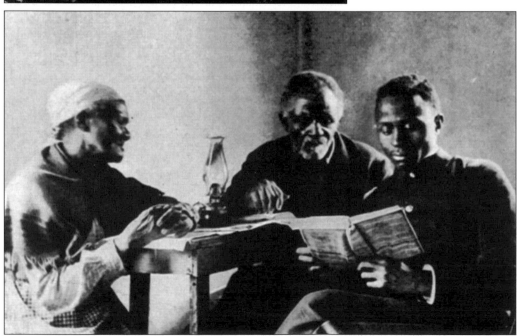

Pictured is a cadet holding a Bible lesson with a couple at the Little England Chapel. (Courtesy of Library of Congress.)

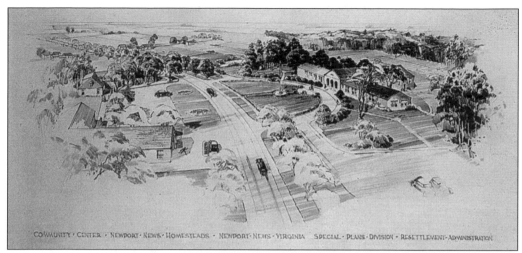

COMMUNITY · CENTER · NEWPORT · NEWS · HOMESTEADS · NEWPORT · NEWS · VIRGINIA SPECIAL · PLANS · DIVISION · RESETTLEMENT · ADMINISTRATION

In 1934, Arthur Howe, principal of Hampton Institute and friend on Franklin Roosevelt, submitted a proposal to improve housing for lower-income citizens on the peninsula. The proposal included a school, community center, and grocery store. The proposal received support from notable community leaders in Hampton and Newport News, and among them was Reverend Patterson of First Baptist Church of Hampton. (Courtesy of Library of Congress.)

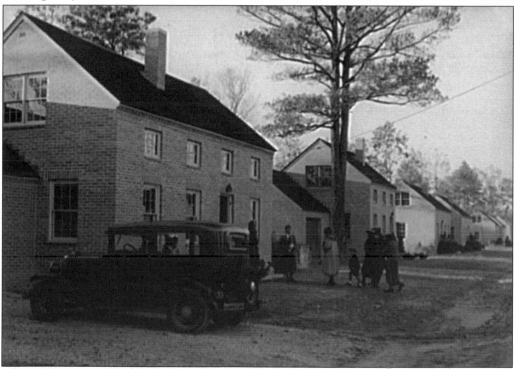

The name Newport News Homestead quickly gave way to Aberdeen Gardens. According to Naomi Johnson, who was among the first to move into the subdivision, it was originally segregated into two sections, which were divided by the main road, but this plan was abandoned. Hampton students built the homes for African American residents. (Courtesy of Library of Congress.)

Pictured are Mann/Curry family graduates of Hampton Institute. These family members believed in the school so much that they have become lifelong members of the alumni association and booster organizations. At center is Dinah Mann who served in the library on campus. (Courtesy of Clarence "Jap" Curry.)

In 1888, General Armstrong recommended that a bank be founded to provide low-interest loans to Hampton graduates and area citizens to purchase homes. The recommendation met with approval, and James Barrett was selected to manage the bank. The first board of directors meeting was held at First African Baptist Church, and the People's Savings and Loan was born. The bank opened in the treasurer's office at Hampton Institute and, later, moved to King Street. (Courtesy of HathiTrust.)

BIBLIOGRAPHY

Armstrong, S.C. *Education for Life*. Hampton, VA: Press of the Hampton Normal and Agricultural Institute, 1914.

"School College Hampton Institute." *Boston Evening Transcript*. April 25, 1898.

Hampton Normal and Agricultural Institute. *Annual Catalogue of the Hampton Normal And Agricultural Institute*. Hampton, VA: Institute Steam Press, 1880–1922.

———. *Twenty-two Years' Work of the Hampton Normal and Architectural Institute*. Hampton, VA: Hampton Normal School Press, 1893.

John, W.C. *Hampton Normal and Agricultural Institute: Its Evolution and Contribution to Education as a Federal Land-Grant College*. Washington, DC: Government Print Office, 1923.

Kuska, Bob. *Hot Potato, How Washington and New York Gave Birth to Black Basketball and Changed America's Game Forever*. Charlottesville, VA: University of Virginia Press, 2004.

Ludlow, H. *Ten Years of Work for Indians at the Hampton Normal and Agricultural Institute*. Hampton, VA: Hampton Normal School Press, 1888.

Ludlow, M.F. *Hampton and Its Students: By Two of its Teachers*. New York, NY: G.P. Putnam & Sons, 1903.

Peabody, Francis Greenwood. *Education for Life: The Story of Hampton Institute*. Garden City, NY: Doubleday, Page & Company, 1918.

"The Museum." *Southern Workman*.

"Hampton Schools." *Southern Workman*.

The Armstrong League of Hampton Workers. *Memories of Hampton*. 1909.

"New Head for Hampton." *New York Times*. December 24, 1917.

"Mr. John S. Kennedy." *New York Times*. February 20, 1893.

Discover Thousands of Local History Books Featuring Millions of Vintage Images

Arcadia Publishing, the leading local history publisher in the United States, is committed to making history accessible and meaningful through publishing books that celebrate and preserve the heritage of America's people and places.

Find more books like this at
www.arcadiapublishing.com

Search for your hometown history, your old stomping grounds, and even your favorite sports team.